50 FINDS FROM WARWICKSHIRE
Objects from the Portable Antiquities Scheme

Angie Bolton

AMBERLEY

First published 2017

Amberley Publishing
The Hill, Stroud
Gloucestershire, GL5 4EP

www.amberley-books.com

Copyright © Angie Bolton, 2017

The right of Angie Bolton to be identified as the
Author of this work has been asserted in accordance
with the Copyright, Designs and Patents Act 1988.

ISBN 978 1 4456 6514 6 (print)
ISBN 978 1 4456 6515 3 (ebook)

British Library Cataloguing in Publication Data.
A catalogue record for this book is available from
the British Library.

Typeset in 10pt on 13pt Celeste.
Origination by Amberley Publishing.
Printed in the UK.

Contents

Acknowledgements

The first thank you must go to Dave Head, who has supported me, encouraged me, has not seen me while writing this book and who has provided comments and feedback, giving me the confidence to continue with it. Ella and Robert Head must also get a mention!

This book could not be written at all if it were not for the finders and landowners of the 28,500 objects the Portable Antiquities Scheme has recorded from Warwickshire. There are too many to name, but your contribution to Warwickshire's archaeology is to be treasured by us all – thank you.

I would like to thank two finders in particular, Mr Andrew Gardner and Mr Robert Laight, who, since the start of the Scheme, have made all their finds and findspots available for recording, have had endless patience and provided the generosity of their time, finds and knowledge. The archaeology of Warwickshire would be impoverished without their contributions.

Many friends and family have proofread this text and I would like to thank them for their encouragement, time and comments: Chrissy Bolton; Katie Hinds; David Williams; Anni Byard; and Peter Reavill. I'd especially like to thank two women who never realised they had such an interest in archaeological small finds until they read this book: Jackie Chown and Caroline Hanagan. Thank you for the help, support, humour and drinks!

I would like to thank Roger Bland, Phil Watson, Sara Wear and David Symons, who set me on the Portable Antiquities Scheme road in 1997 and have supported me ever since.

There are many volunteers who work with the Portable Antiquities Scheme and their help, company and hard work are much appreciated; in particular Carina Hughes and Rob Lythe.

All images, unless otherwise stated, are courtesy of the Portable Antiquities Scheme. Other images are reproduced with many thanks to and with the kind permission of Candy Stevens, David Williams, Mike Trevarthen, Ciorstaidh Hayward Trevarthen, Ros Tyrell, Museums Worcestershire and Archaeophysica.

If I have inadvertently used copyright material without permission or the appropriate acknowledgement, I apologise and will rectify this at the first opportunity.

Introduction

These 50 finds from Warwickshire are objects and coins that have been recorded by the Portable Antiquities Scheme. The Scheme is funded by the British Museum and employs a network of dedicated Finds Liaison Officers and Finds Advisers, who record archaeological objects discovered not by archaeologists, but members of the public. Finds may be discovered whilst gardening, walking across fields or using a metal detector. The purpose of the recording is to advance our knowledge of history and archaeology locally, nationally and internationally.

The Finds Liaison Officers work closely with metal detector users, who find the majority of recordable archaeological metalwork.

When a Finds Liaison Officer talks about recording an object, they borrow the finds, take high-quality images, identify and date them, write a detailed description and add this data to the Portable Antiquities Scheme database (www.finds.org.uk/database), recording exactly where they were found.

Finders mark the position of their finds on a map or provide an Ordnance Survey national grid reference. Many metal detectorists now use handheld Global Positioning Systems (GPS) to gain a more accurate findspot. The Portable Antiquities Scheme database can be used online by anyone, whether researching finds from their parish or trying to identify their own finds before passing them to a Finds Liaison Officer. A find with an

Portable
Antiquities
Scheme

www.finds.org.uk

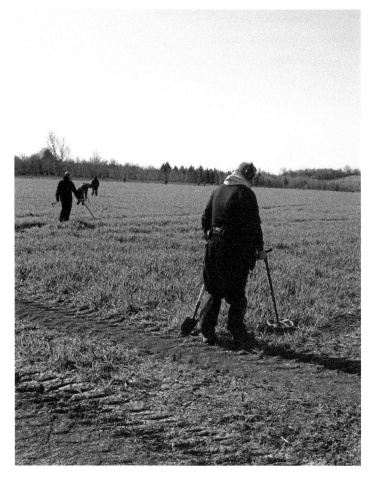

Metal detector users are responsible for finding the vast majority of artefacts recorded on the Portable Antiquities Scheme database: www. finds.org.uk/database. (Angie Bolton)

accurate and precise findspot is archaeologically priceless, no matter what the find. This crucial findspot detail allows spatial analysis of the distribution of finds, and adds to the stories of past people, communities and ways of life. Finds without a findspot are a wasted opportunity for these stories to be enriched and told to a global audience, and the finds are, therefore, of no archaeological benefit now or in the future.

Each of the finds mentioned in this book is also given its unique Portable Antiquities Scheme database code, such as WAW-123456 or BERK-123456. This can be searched for on the Scheme's database.

The Portable Antiquities Scheme has recorded over 28,500 finds from Warwickshire since the Scheme started in 1997.

These finds range from c. 500,000 BC Palaeolithic handaxes to twentieth-century finds such as fragments of Second World War aircraft. The 50 finds contained in this book are the author's personal choices. They are finds recorded over the last twenty years, including those that are of national importance through to common 'everyday' items, and the archaeological landscape they all help to reveal is breathtaking. All of these discoveries have been recorded by the Portable Antiquities Scheme, becoming the finder's legacy and contributing to Warwickshire's archaeology.

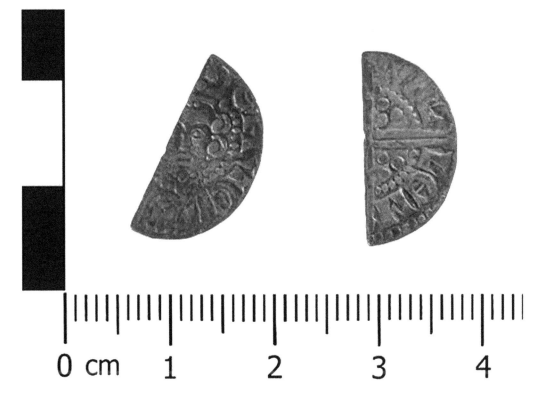

An example of a Portable Antiquities database record showing a cut halfpenny of Henry III. (WAW-AEB1A2)

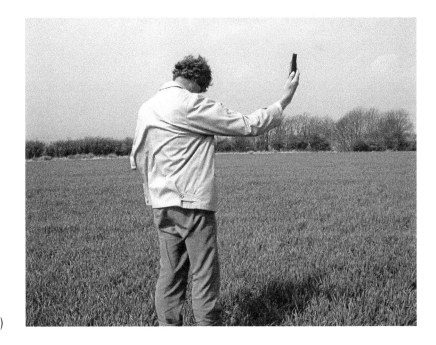

A GPS being used to plot a findspot. This is the best practice for all finds. (Angie Bolton)

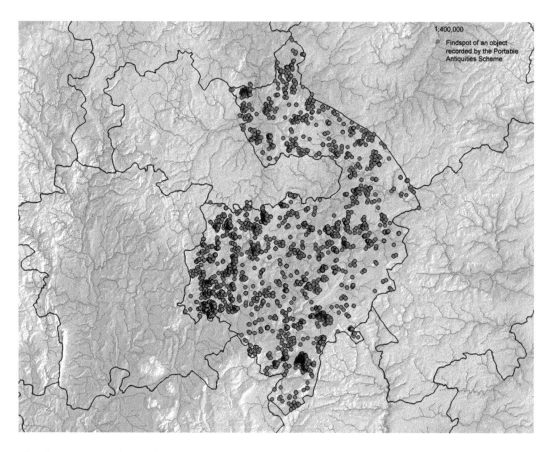

The findspots of all Portable Antiquities Scheme finds recorded in Warwickshire. (*Contains OS data © Crown copyright and database rights 2017*)

Many of the finds recorded on the Portable Antiquities Scheme database are returned to the finder once recorded, some of which are then kindly donated to museums, while others have to be legally reported to the Coroner under the Treasure Act (1996), which in summary is:

 i) Any metallic object, other than a coin, at least 10 per cent gold or silver, and more than 300 years old.

 ii) Any group of two or more metallic objects of prehistoric date that come from the same find.

 iii) Two or more coins, at least 10 per cent gold or silver, more than 300 years old and of the same find.

 iv) Ten or more coins with less than 10 per cent gold or silver, more than 300 years old and of the same find.

 v) Any object, whatever it is made of, which is found in the same place as, or was originally deposited with, another object that is Treasure.

 vi) Any object that would have been treasure trove, is made of substantially gold or silver, is less than 300 years old and whose heirs or owners are unknown.

Chapter 1

The Character of Warwickshire's Landscape and Archaeology

Warwickshire is a county in the West Midlands, bordered by Worcestershire to the west, Gloucestershire to the south, Leicestershire to the east, and the West Midlands and Staffordshire to the north. The modern boundaries of Warwickshire are used for the purposes of this book.

The landscape of Warwickshire can be divided into five topographical areas: North Warwickshire, Dunsmore, the Arden, the Avon Valley and the Feldon area. In each area the landscape has influenced how people have lived there from prehistory to the present day.

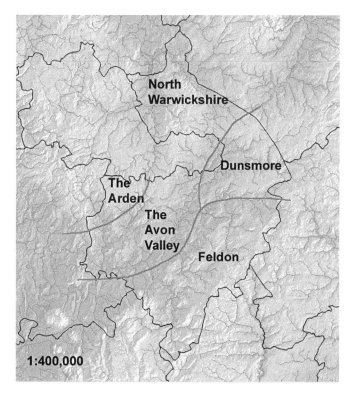

The outline of Warwickshire with details of the five topographical areas. (*Contains OS data © Crown copyright and database rights 2017*)

North Warwickshire

The North Warwickshire area comprises of the highlands of the Nuneaton to Atherstone ridge and the lowlands of the Trent Valley. The major settlements in this area include Nuneaton, Bedworth, Atherstone, Polesworth and Coleshill, with Coventry, Sutton Coldfield, and Tamworth just beyond its borders.

The prehistory of North Warwickshire is not as well known as other areas, such as the Avon Valley, but this is changing as fieldwork occurs ahead of modern building and infrastructure development, as chance finds are recorded with the Portable Antiquities Scheme and as the further study of cropmarks is made from aerial photographs.

The Avon Valley

The Avon Valley starts at Warwick and continues towards the south-west into Worcestershire, consisting of fertile alluvial deposits on the lowland. There is evidence that the Avon Valley has been well populated since prehistory. Along the valley there are a number of long-established settlements, including Stratford-upon-Avon, Welford-on-Avon and Bidford-on-Avon.

The Arden

The Arden is the area to the north of the Avon Valley, and includes towns such as Henley-in-Arden, Tanworth-in-Arden and Studley. This area has poorer soils and was heavily wooded after the early medieval period. The settlement pattern reflects this wooded landscape and there are more dispersed hamlets and farmsteads rather than larger towns seen in other areas.

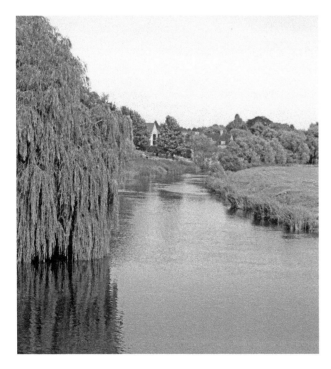

The River Avon at Bidford-on-Avon. (Angie Bolton)

A typical view of the Arden landscape near Great Alne. (Angie Bolton)

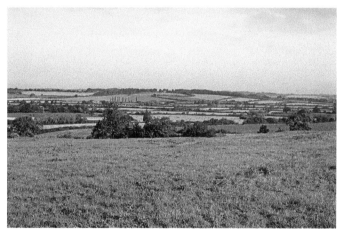

The Feldon landscape looking west from Brailes towards Shipston-on-Stour. (Angie Bolton)

The Feldon Area

The Feldon area covers the south-east portion of Warwickshire, with the Avon Valley to the north-west and Dunsmore to the north-east. Towns in the Feldon area include Shipston-on-Stour, Wellesbourne, Southam and Warwick. The Feldon covers an area that is fertile, whose woodland was greatly reduced before the early medieval period, and whose settlement pattern consisted of larger villages, as well as farms and large houses.

The Feldon area now has a gently undulating landscape which overlies calcareous clays with lighter soils in the valleys. Along its south-east border, the Feldon has the highest points in Warwickshire.

The Dunsmore Area

The Dunsmore area was once heathland located on a low plateau between Coventry, Rugby and Royal Leamington Spa. The landscape is similar to the Feldon area, but has poorer, lighter soils. There is evidence that the Dunsmore area was settled in prehistory, with numerous cropmarks revealing settlement locations. Today, Rugby is the largest town in the Dunsmore area, and is surrounded by smaller villages such as Stretton-on-Dunsmore and Bourton-on-Dunsmore.

Chapter 2

The Stone Age in Warwickshire

Palaeolithic to Early Bronze Age (*c.* 500,000 BC to *c.* 1,600 BC)

The Stone Age covers the Palaeolithic, Mesolithic and Neolithic periods, from about 500,000 BC to ditto 2,350 BC. We know that during this time people made artefacts out of many materials. Stone and flint tools are most commonly linked to the period because they survive very well. However, people at the time also made use of organic materials such as wood, bone, plant fabrics and animal products, such as sinew and leather, but these rarely survive. When metal tools were developed during the Bronze Age people did not give up working with stone and flint, although as time went by these skills slowly declined.

Evidence for human activity is first seen in the Lower Palaeolithic period in Warwickshire (*c.* 500,000 to *c.* 150,000 BC); some of the oldest handaxes in the country were found at Waverley Wood near Leamington Spa. These tools were found with the fossilised remains of straight-tusked elephants, horses and water voles. The Portable Antiquities Scheme has recorded only one Palaeolithic tool from Warwickshire. The low number of such finds recorded is partly due to the tools of this period being very rare and finders not recognising stone when it has been shaped (knapped) to form such implements.

The Palaeolithic period is followed by the Mesolithic period (*c.* 10,000 to *c.* 4,000 BC), a time when many people were transitory, commonly living in small groups as hunter-gatherers and moving through the landscape, perhaps following migrating herds. It was in the Mesolithic period when the variety of flint and stone tools increased to include different types of axes and knives. Examples of these tools from Warwickshire have been recorded by the Portable Antiquities Scheme, pinpointing where human activity at this time was taking place. As well as these, the Portable Antiquities Scheme has recorded waste material – the flakes of flint removed during the manufacturing process. These discoveries are potentially more important than the actual tools as they provide evidence of where people actually camped or lived.

The transition into the Neolithic period (4,000 BC to 2,350 BC) is marked by the slow move toward a more sedentary lifestyle, with the beginning of primitive agriculture. As farmers domesticated livestock and planted crops, the character of the landscape started to change; people began to settle in one place and deforestation provided fuel and cleared the land for farming.

The use of worked stone and flint tools and arrowheads continued into the early Bronze Age (2,350 BC to 1,600 BC) and existed alongside new luxury goods made of metal. As metalwork became more common, a slow decline in knapped tools began.

It is mainly metal detectorists and field-walkers who see the worked flint and stone, and who report them to the Portable Antiquities Scheme or their local Historic Environment Record. By recording finds of flint, the work of the public is having a great impact on our knowledge of Stone Age Warwickshire.

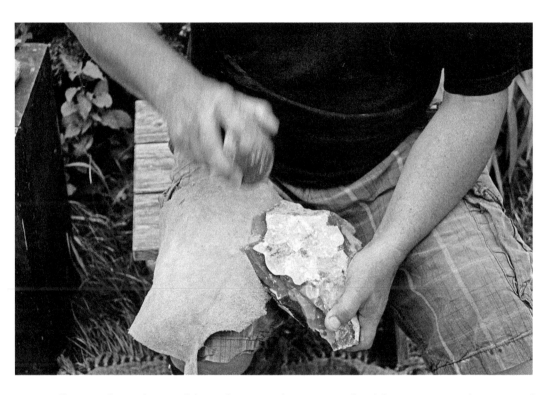

A flint axe being knapped by Mike Trevarthen using a hard hammer stone. (Courtesy of Mike Trevarthen)

1. Handaxe (WAW-7538B2)
Middle Palaeolithic (*c.* 150,000 BC to *c.* 40,000 BC)
Found in 2005 near Bidford-on-Avon.

Handaxes are the most common type of tool found from the Middle Palaeolithic (Old Stone Age). These implements, which were held in the hand rather than hafted on a wooden handle, were used for a variety of purposes, including butchery and scraping animal hides. A complete axe of this date usually has a pointed tip, which could be used to dismember animal carcasses.

The Bidford-on-Avon handaxe has been knapped from flint and has since developed an orange-yellow patina as the surface has, over time, reacted to the soil. The edges of the handaxe are not the original edges; these have been damaged from antiquity through to recent times as the axe has tumbled in the soil.

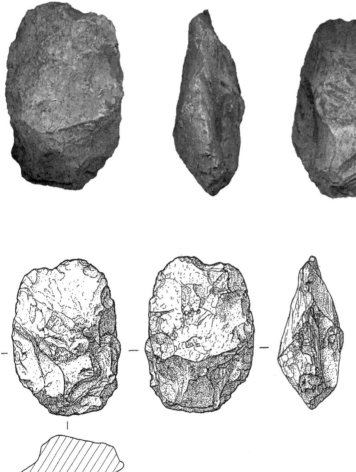

Above: The Bidford-on-Avon handaxe showing the patina that has developed, which colours the surface. (WAW-7538B2)

Left: A technical drawing of the Bidford-on-Avon handaxe illustrating each crevice, scar and chip on its surface. (Illustrated by Candy Stevens)

2. Tranchet axehead (WAW-91AC18)
Mesolithic (*c.* 8,300 BC to *c.* 4,500 BC)
Found in 2009 near Aston Cantlow.

The Aston Cantlow axe is an unfinished Mesolithic tranchet axehead, which was knapped from flint or chert and whose surface is now a mottled brown/yellow colour, but which would have originally been grey. As flint reacts to the soil over a long period of time, its colour and texture changes, and it forms a patinated surface.

The axe is unfinished as the blade has not yet been created by removing a large flake across one terminal, which would have created a sharp edge.

This type of axe was hafted into a wooden handle or antler sleeve and may have been used for woodworking – such as boatbuilding – rather than for cutting down trees.

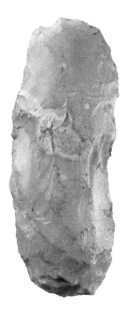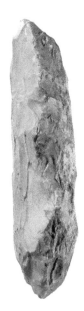

The Aston Cantlow Mesolithic tranchet axehead. (WAW-91AC18)

15

3. Pebble hammer or mace head (WAW-BA8194)
Mesolithic to Neolithic (*c.* 8,300 BC to *c.* 3,500 BC)
Found in a garden in Arrow with Weethley during 2007.

Stone pebble hammers, or mace heads, date from the late Mesolithic to the early Bronze Age. It is uncertain what this tool was actually used for; theories include that it was a type of weapon, hammer or weight. The Arrow with Weethley example gives us no clues as to its function, but the effort taken to make the hole, by hand, suggests it was a prestige item.

The hole in the centre may have been made by grinding and rubbing an antler in a circular motion using sand and water to provide more friction. A hole made in this manner has an hourglass profile and can take hours to create.

The Arrow with Weethley hammer is made from hard sandstone that has worn smooth in a river. Such pebbles are widely distributed throughout the Midlands, but only a few have been shaped into tools.

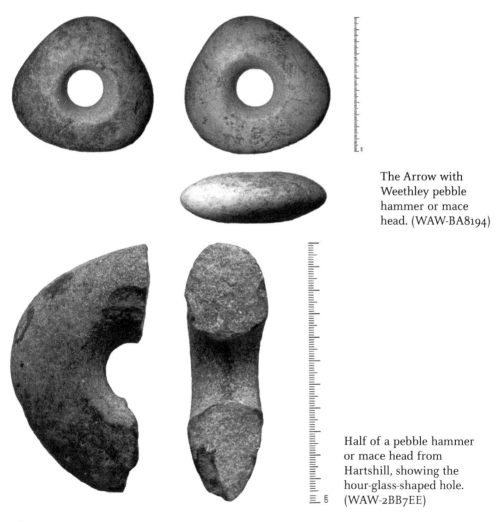

The Arrow with Weethley pebble hammer or mace head. (WAW-BA8194)

Half of a pebble hammer or mace head from Hartshill, showing the hour-glass-shaped hole. (WAW-2BB7EE)

16

4. Flint knife (WAW-18F662)
Neolithic (c. 2,900 BC to c. 1,800 BC)
Found in 2012 near Brailes.

In the Neolithic period, flint was used to make a variety of tools, including this knife found near Brailes. When tools are made from flint, flakes are removed using a hammer stone to form the tool. This knife has been knapped from a large waste flake, whose surface had started to react to the soil, changing the colour of the flint from a dark grey to a light, speckled grey.

At a later date in prehistory, the flake was rediscovered and smaller flakes were then removed from one surface, making the knife thinner and revealing the dark grey flint beneath the patina. The removal of these small flakes across the surface is called invasive re-touch.

The knife is thicker along one long edge, so it could have been held in the hand or hafted onto a wooden handle. The other long edge is the cutting edge, which was sharpened by removing small flakes or chips of flint along its length.

Flint is not natural to Warwickshire, so the raw material was either imported by someone or it was left behind by a glacier as it receded when the climate became warmer.

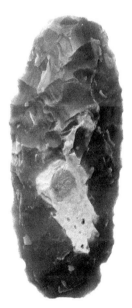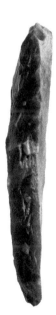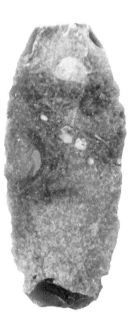

The Brailes flint knife, showing one face having had invasive re-touch and the other face still having the patinated surface. (WAW-18F662)

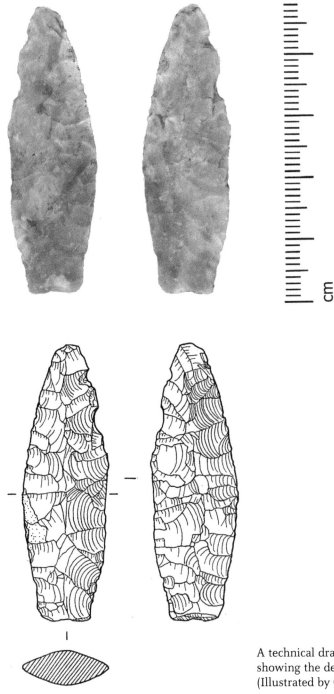

A Neolithic knife from Ilmington showing invasive re-touch on both faces. (WAW-8C6966)

A technical drawing of the Ilmington knife showing the detail of the invasive re-touch. (Illustrated by Candy Stevens)

5. Barbed and tanged arrowhead (WAW-29BE65)
Bronze Age (*c.* 2,500 BC to *c.* 1,500 BC)
Found near Weston-under-Wetherley in 2011.

Barbed and tanged arrowheads date to the early Bronze Age and the example from Weston-under-Wetherley was knapped from a dark grey flint.

Flint was used to make arrowheads in earlier periods, but the arrowheads were of different shapes; early Neolithic (*c.* 4,000 – *c.* 3,500 BC) arrowheads were leaf-shaped and later Neolithic (*c.* 2,700 – *c.* 2,350 BC) arrowheads were triangular, with a hollow base – the so-called 'oblique' type.

The use of the tang on Bronze Age arrowheads enabled it to be fixed securely to the shaft and once the arrowhead had pierced the animal, the barbs would not have allowed the arrowhead to fall out, thereby keeping the wound open and allowing the arrowhead to be re-used.

Barb and tanged arrowheads may have been lost when used for hunting, but they are also found in burials.

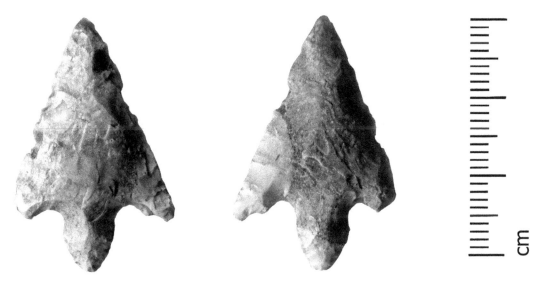

An early Bronze Age barbed and tanged arrowhead from near Weston-under-Wetherley. (WAW-29BE65)

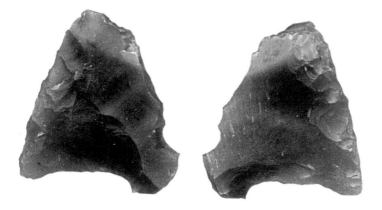

Later Neolithic oblique arrowhead from near Bidford-on-Avon. The tip is missing. (WAW-09BFD7)

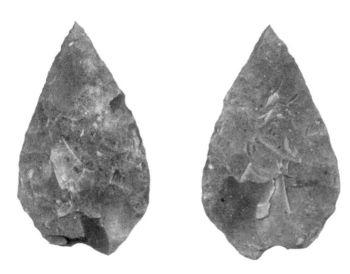

Early Neolithic leaf-shaped arrowhead from Dunchurch. (WAW-42E601)

Chapter 3

The Bronze Age
in Warwickshire

(*c.* 2,350 BC **to** *c.* 800 BC)

In Britain, the use and working of metal began about 2,350 BC, initially with gold and copper, but the latter was then superseded by bronze (copper alloyed with tin and eventually lead). Flint implements were used for much of the Bronze Age, but the quality and quantity lessened over time.

The range of objects that were cast in bronze is diverse. As well as tools such as axes, chisels and hammers, personal artefacts, pins and razors, for example, were also manufactured. The production of weapons increased, including swords, rapiers and spearheads. Some of these were highly decorated, while others were undecorated and functional.

The majority of archaeological sites and settlements in Warwickshire are centred around the Avon Valley and stretch into the Dunsmore area. However, this distribution may not reflect the true picture. Instead, it may only reflect the areas where cropmarks on aerial photographs are visible, where recent archaeological fieldwork has been carried out and where metal detector users have permission to detect and have their finds recorded.

6. Hammer (WAW-75FD95)
Bronze Age (c. 800 BC to c. 700 BC)
Found near Stratford-upon-Avon while metal detecting in 2016.

The weight of the Stratford-upon-Avon bronze hammer indicates a high lead content, which dates it to the later Bronze Age period. Later Bronze Age artefacts, such as axes and spears, had a larger proportion of lead mixed with the copper, making them heavier compared to artefacts from the early and middle Bronze Age.

Bronze Age socketed hammers are not common, with only forty-one examples recorded on the Portable Antiquities Scheme database. This hammer is one of only three known from the West Midlands; two are from Warwickshire and the third is from Worcestershire.

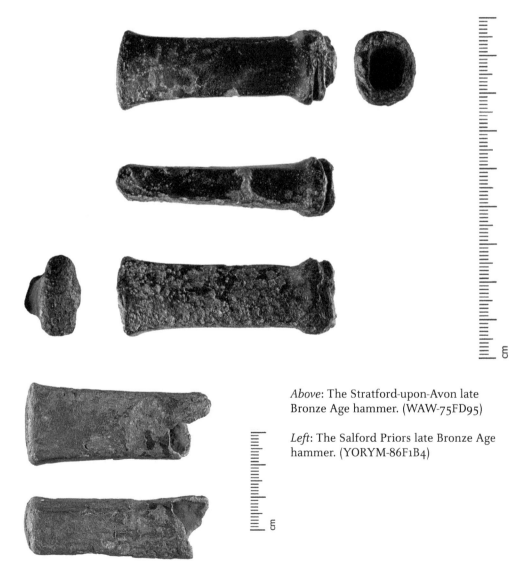

Above: The Stratford-upon-Avon late Bronze Age hammer. (WAW-75FD95)

Left: The Salford Priors late Bronze Age hammer. (YORYM-86F1B4)

7. Socketed axe (WAW-C2E756)
Late Bronze Age (*c.* 1,000 BC to *c.* 800 BC)
Found near Alcester while metal detecting in 2008.

Axes evolved through the Bronze Age, starting with the flat axe in the early Bronze Age, which developed into the palstave in the middle Bronze Age and ended with the socketed axe in the later Bronze Age.

The socketed axes were used for chopping wood and other organic matter, but some axes are thought to have been made as votive offerings rather than as functioning axes.

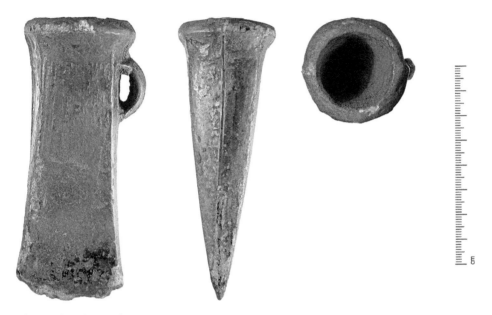

Above: The Alcester late Bronze Age socketed axe, which allows a handle to be inserted into the socket. (WAW-C2E756)

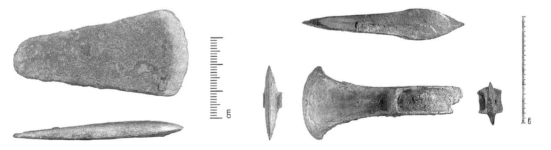

Left: Flat axe from Brailes, which is flat in profile and tapers towards the cutting edge. (WAW-049216)

Right: Palstave from Clifton-upon-Dunsmore, which has a ridge for the handle to butt against and raised sides. (WAW-245FB6)

8. Penannular ring (WAW-F3AE27)
Bronze Age (c. 1,150 BC to c. 750 BC)
Found near Radway while metal detecting in 2005.

Penannular rings were formerly known as 'ring money', but this was a misleading title as we do not know their exact function. It has been hypothesised that they may be a form of hair accessory or body ornament.

The rings date to the late Bronze Age and it was at this time that new techniques of goldworking were developed, such as gold-plating, sheet-working and soldering. Gold-plating (also known as gold foil covering) involves fixing a thin layer of gold onto another metal. Sheet-working is the technique of hammering a gold nugget or ingot into a sheet. Soldering is the method by which you adhere two metal surfaces together with the use of another metal.

The Radway penannular ring has a solid gold core, around which narrow stripes are formed by using three different colours of gold. The metal detectorist and landowner kindly donated this penannular ring to the Warwickshire Museum.

Another example of a penannular ring from Warwickshire has been found near Wixford, but this has a copper alloy core and subtle two-tone gold striping.

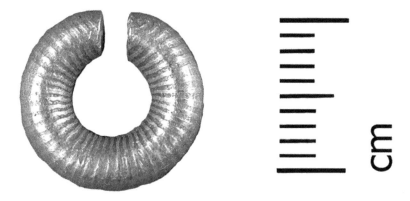

The Radway penannular ring with three-tone gold stripes. (WAW-F3AE27)

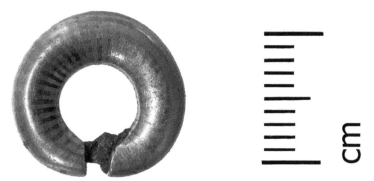

The Wixford penannular ring with two-tone gold stripes and a copper alloy core. (WAW-97DE52)

9. Razor (WAW-878535)
Bronze Age (*c.* 1,150 BC to *c.* 800 BC)
Found near Bidford-on-Avon while metal detecting in 2004.

The Bidford-on-Avon copper-alloy, leaf-shaped razor dates to the late Bronze Age. This type of razor has a cutting edge running the length of both curved sides and has a slight central mid-rib on one face, which strengthens the blade and provides some decoration. In profile, the Bidford-on-Avon razor blade is bent at the tip, which is probably due to recent damage in the plough soil.

Bronze razors are relatively rare and are usually found within hoards, or are associated with burials, thereby indicating they were important objects. One theory suggests they were important as they had the ability to significantly change the male appearance, thereby making that individual stand out and be noticed.

Bronze Age razors have been found at later Iron Age sites, which suggests they had become heirlooms and were highly valued.

The finder and landowner kindly donated this razor to the Warwickshire Museum.

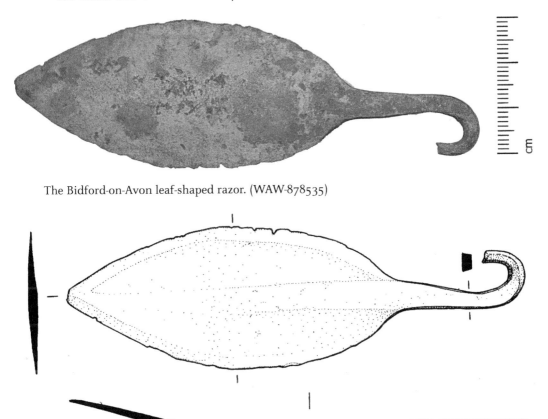

The Bidford-on-Avon leaf-shaped razor. (WAW-878535)

A technical drawing of the Bidford-on-Avon leaf-shaped razor. (Illustrated by Angie Bolton)

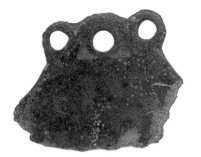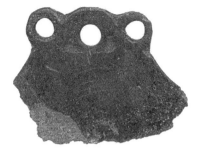

There are different types of Bronze Age razor. This is an incomplete example from Brailes. (WAW-FB0A73)

10. Pottery (WAW-45A5D7, WAW-457AC3 and WMID-72EE35)
Bronze Age to Iron Age (*c.* 2,150 BC to *c.* 300 BC)
Found near Brailes.

Bronze Age and Iron Age pottery is rarely found due to its fragility when compared to modern pottery, which is fired at a high temperature for a long period, thereby producing a robust pot. The pots of the Bronze Age and early Iron Age were fired on open bonfires, so the temperature varied and high temperatures were not sustained.

A site in Brailes has produced little metalwork, but more unusually, at the time of writing, has produced over 800 sherds of late Bronze Age and early Iron Age handmade pots. The finder collected these sherds and plotted exactly where each individual sherd was found using a handheld Global Positioning System (GPS). Using the data that these findspots created, archaeologists were confident that a prehistoric site had been found, but did not know whether this was a settlement or a late Bronze Age rubbish tip (midden site).

Due to the precise findspot recording of each sherd, a geophysical survey was carried out, which revealed a late Bronze Age and early Iron Age settlement consisting of roundhouses and enclosures, all of which were invisible on the surface.

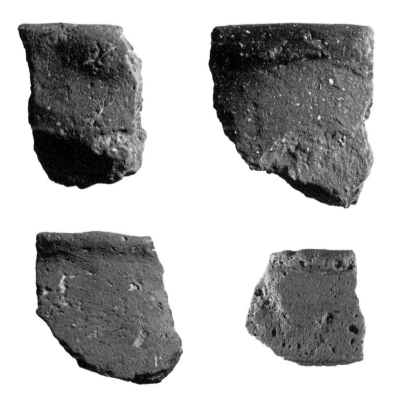

Examples of late Bronze Age and early Iron Age pottery sherds.

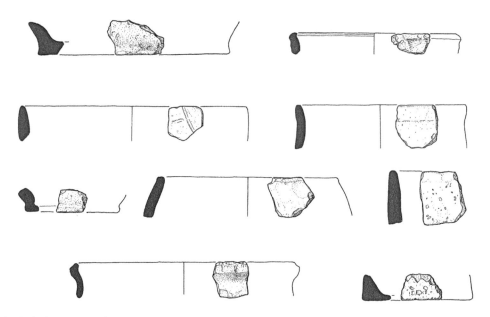

Technical drawings of some of the late Bronze Age and early Iron Age pottery sherds. (Illustrated by Candy Stevens)

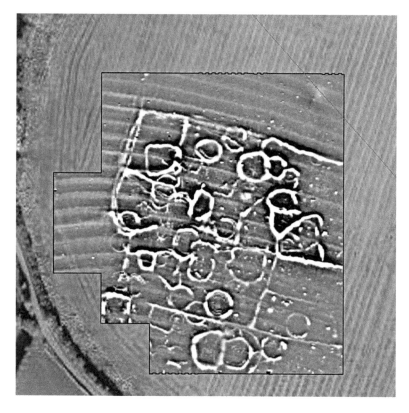

The geophysics results, which illustrate the roundhouses and enclosures of the late Bronze Age and early Iron Age. (Courtesy of Archaeophysica)

11. Miniature axe (WAW-80FB93)
Bronze Age to Roman (*c.* 1,150 BC to *c.* AD 410)
Found near Claverdon while metal detecting in 2013.

Copper-alloy miniature axes are copies of full-sized socketed axes of the late Bronze Age. There is an element of confusion in dating these miniature axes as despite replicating Bronze Age axes, they are commonly found on Roman sites. The surface condition of many of these axes suggest a late Bronze Age date rather than a Roman date, and this is the case with the Claverdon example.

Miniature axes, in general, are thought to be a type of votive object made in the late Bronze Age, which became heirlooms that were passed down over a number of generations to later be found on Roman sites. The Romans are also known to have used miniature objects, and in particular axes, at shrine sites, and they may have been associated with a particular god or deity. Miniature axes are also found in burials or in hoards.

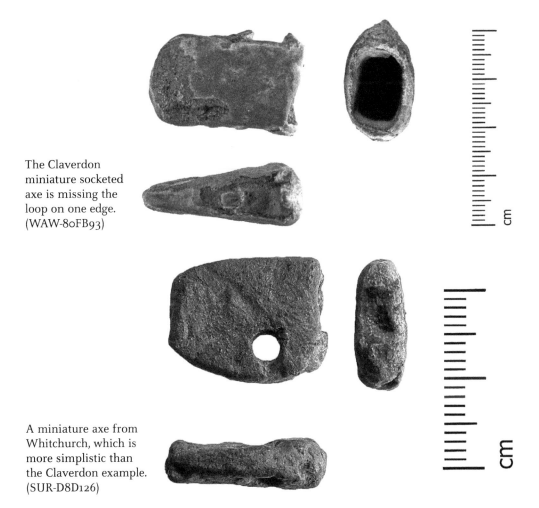

The Claverdon miniature socketed axe is missing the loop on one edge. (WAW-80FB93)

A miniature axe from Whitchurch, which is more simplistic than the Claverdon example. (SUR-D8D126)

29

Chapter 4
The Iron Age in Warwickshire

(*c.* 800 BC to AD 43)

Warwickshire in the Iron Age was dotted with small farmsteads or clusters of dwellings. People were commonly living in small, round, thatched buildings with their livestock close by. There are at least eight Iron Age hill forts, possibly more, in Warwickshire, including Meon Hill near Mickleton where the earthworks are still visible today. The exact purpose of the hill forts is not known; they may be where people took refuge in times of trouble or they may have been used for ceremonial purposes.

It was during this period that iron started to be used; however, very few iron artefacts have been discovered or recorded from this period by the Portable Antiquities Scheme. The reasons for this are varied. Iron survives poorly in the soil as it rusts away due to its contact with moisture and air. Another reason is that metal detectorists deliberately set their machines to discriminate against iron to avoid modern material, as many modern artefacts are either made of or contain iron. The result is that the older iron artefacts are not found. In Warwickshire, the finds we do see from the Iron Age include pottery, bronze artefacts and coinage.

The borders of two tribal groups meet in Warwickshire – the Dobunni to the west and to the south and the Corieltauvi to the north. The boundary for the territories of each tribe is not certain, however coinage distributions suggests the boundary bisects Warwickshire from Tanworth-in-Arden to beyond Shipston-on-Stour.

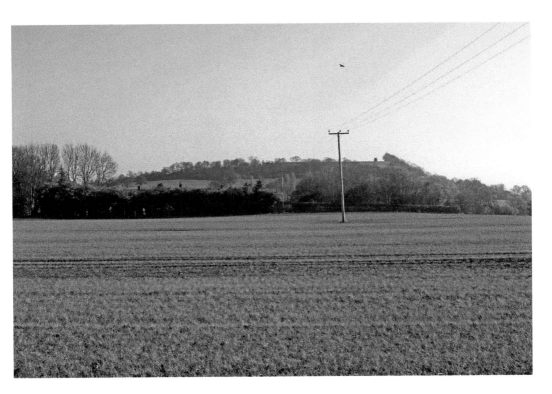

A north-facing view of the hill fort on Meon Hill. (Angie Bolton)

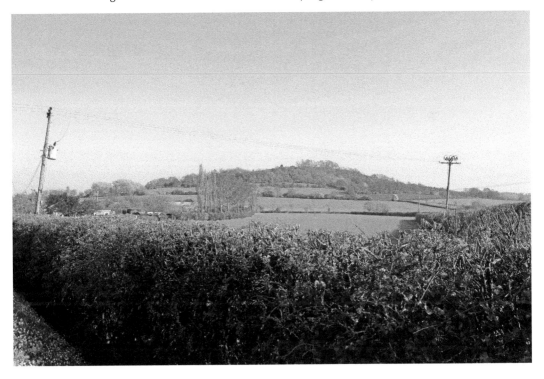

A north-west-facing view of the hill fort on Meon Hill. (Angie Bolton)

12. Miniature shield (WAW-9BB642)
Iron Age (c. 400 BC to c. AD 43)
Found in 2004 while metal detecting near Alcester.

The Alcester miniature shield was made from cast copper alloy and replicates a full-sized mid- to late Iron Age shield. It is oval with a circular dome in the centre, which represents the shield boss. On the reverse, the dome is hollow and has a separate handle, which has been riveted onto the shield. Decoration on the outer face consists of a single fine linear grooved border, and within the border there is a series of dots forming a droplet above and below the boss.

Full-sized shields were made of wood and were covered with leather or metal sheeting and do not often survive. The miniature shields are more robust and therefore more likely to survive, providing us with a glimpse as to what a full-sized shield would have looked like.

Few miniature shields of this date have been excavated, so their purpose is not certain. On mainland Europe, examples have been found in male burials, and groups of such shields have been discovered on religious sites. Could the examples found in burials have been a type of ritual offering? Could the miniature shield have represented the warrior status of the person it was buried with? Could it have merely been a dress accessory such as a brooch, which was suspended by a strap or chain?

The Alcester miniature shield is on display at the Warwickshire Museum.

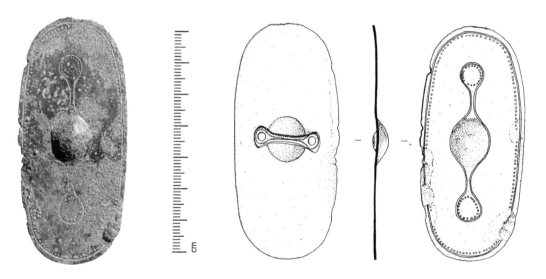

Left: The Alcester miniature late Iron Age shield. (WAW-9BB642)

Right: Drawing of the Alcester miniature shield showing the profile and reverse. (Illustrated by Candy Stevens)

13. Tankard (WMID3150)
Iron Age (*c.* 300 BC to *c.* 100 BC)
Found in 2001 while metal detecting near Tanworth-in-Arden.

British Iron Age tankards were made of wooden staves with thin bronze bands on the exterior, and had one or two bronze handles. Complete tankards are rarely found due to the wooden element perishing, usually leaving the handles as the only remaining evidence. The Tanworth-in-Arden handle is incomplete, as only half of the handle remains. The handle would have been riveted on to the tankard through the rivet hole. The opposite edge is broken at the apex, therefore we can only surmise that the other half of the handle was a duplicate of this one.

The handle was cast in a 'lost wax' mould, which could only be used once. Lost wax casting involves making the object in wax first. Thin layers of fine clay are placed around this wax version of the artefact, which fit snuggly over the wax object. Once all the layers of clay cover the artefact – with the exception of some holes at one edge – the mould is turned so that these holes point downwards and the clay and wax is heated. As the clay is heated, the wax melts and drips out of the holes and the clay hardens (*refer to Find 14 for an illustration*). Once this has occurred, you are left with an empty clay mould into which molten metal is poured. Once the metal has cooled and solidified, the clay mould can be broken and what is left is the artefact in metal. All it then requires is polishing and perhaps decorating, like this example.

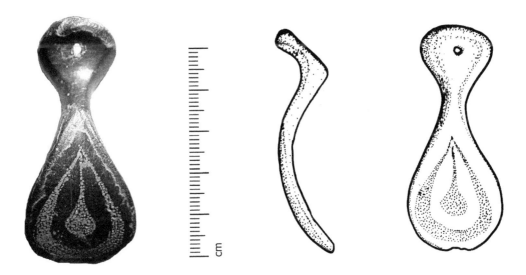

Left: The Tanworth-in-Arden tankard handle, of which only half remains. (WMID3150)

Right: A drawing showing the profile view of the handle and the broken edge. (Illustrated by Angie Bolton)

14. Linch pin terminal (WAW-CEE943)
Iron Age (c. 200 BC to c. 100 BC)
Found in 2007 while metal detecting near Wibtoft.

A linch pin holds a wheel in place on the axle of a vehicle. In the Iron Age, these pins were usually made of iron and had square cross-sections, with a copper-alloy terminal at each end that provided decoration, while also preventing the pin from slipping.

In mainland Europe, Iron Age linch pin terminals are a relatively common find, whereas in Britain they were used only towards the end of the Iron Age period.

The Wibtoft linch pin terminal is decorated with red enamel, which was the most common coloured enamel used in the late Iron Age. Before enamelling occurred in the Iron Age, red coral was sometimes used to decorate objects. However, as coral was a rare commodity, it is thought that once enamelling was developed, red enamel was used to copy the appearance of coral. A harness mount illustrated with Find 16 is decorated with coral.

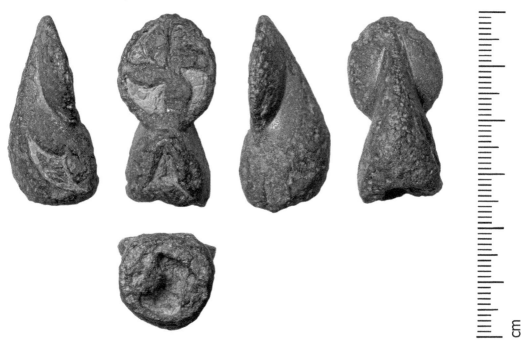

The Wibtoft linch pin terminal showing the red enamel and a trace of the square-sectioned iron pin at the base. (WAW-CEE943)

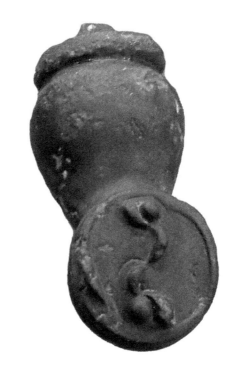

cm

A different style of linch pin terminal from near Kingsbury. (WMID720)

A reconstruction of the 'lost wax' casting method of the Kingsbury linch pin terminal.

15. Harness mount (WMID5608)
Iron Age (c. 200 BC to c. 100 BC)
Found in 2007 while metal detecting near Tanworth-in-Arden.

In the Iron Age, people of high status decorated their horses and vehicles as a method of displaying their wealth and standing in the community. Artefacts associated with horses and vehicles include harness mounts, terret rings (a loop through which the reins pass) and linch pin terminals.

In the West Midlands, including Warwickshire, there is evidence that vehicles and horses were more highly decorated with metalwork than people. The objects associated with people, such as brooches, cosmetic pestle and mortars and tankards, are less common. This pattern is not seen throughout the country; artefacts associated with people are more common than those associated with horses and vehicles.

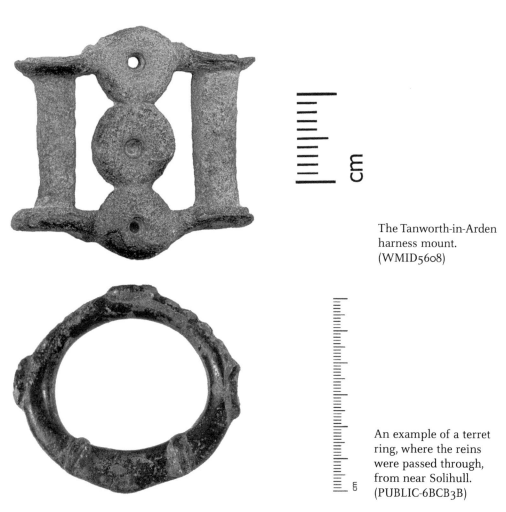

The Tanworth-in-Arden harness mount. (WMID5608)

An example of a terret ring, where the reins were passed through, from near Solihull. (PUBLIC-6BCB3B)

16. Harness mount (WMID410)
Iron Age (*c.* 200 BC to *c.* AD 100)
Found from 1999 onwards while metal detecting near Kingsbury.

The Kingsbury mount is a type of harness mount in the form of an ornate figure-of-eight with two loops on the reverse to allow it to be attached to a harness. The mount is in three separate pieces; three of the breaks are due to recent damage, but the fourth break is different – the edges of this break have a smooth surface, whose colour matches the outer surfaces of the mount, suggesting that it was broken in antiquity. The break does not quite join, instead leaving a gap in the frame, which may not be accidental, but intentional. Why the mount has this gap is uncertain.

The metal detector user found the three fragments of the mount separately in the same field over three consecutive years.

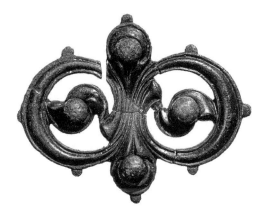

The Kinsgury harness mount showing the three fragments. (WMID410)

An example of an Iron Age harness mount from West Sussex, which has been decorated with red coral. (SUSS-F35BF5)

17. *Stater* (WAW-6ADF25)
Iron Age (*c.* 10 BC to *c.* AD 20)
Found in 2004 while metal detecting near Tanworth-in-Arden.

The Tanworth-in-Arden coin is a late Iron Age gold quarter stater, which was struck between about 10 BC and AD 20 for Corio, a ruler of the Dobunni tribe. The coin depicts a horse and a sunburst motif on the reverse and is inscribed COR on the obverse, which is the abbreviation of Corio.

Single Iron Age coins are often found on natural boundaries within the landscape, such as streams. These coins were perhaps not used as currency as we use coins today, but were imbued with other powers, which had more votive connotations rather than economic ones. Placing coins on boundaries may be a form of marking out territories or communities, and with the powers imbued in the coins, those communities may have felt protected.

As more Iron Age coins are recorded through the Portable Antiquities Scheme and elsewhere, it is becoming apparent that the coins were travelling wide distances and were being exchanged between different tribes. In the West Midlands there are coins from fourteen different tribes; some of those are from as far away as mainland Europe, suggesting trading links and the migration of people.

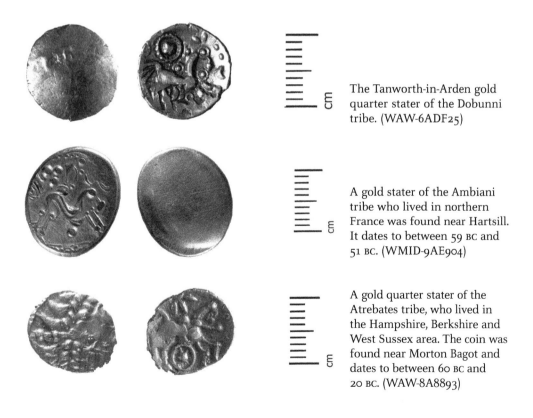

The Tanworth-in-Arden gold quarter stater of the Dobunni tribe. (WAW-6ADF25)

A gold stater of the Ambiani tribe who lived in northern France was found near Hartsill. It dates to between 59 BC and 51 BC. (WMID-9AE904)

A gold quarter stater of the Atrebates tribe, who lived in the Hampshire, Berkshire and West Sussex area. The coin was found near Morton Bagot and dates to between 60 BC and 20 BC. (WAW-8A8893)

18. Comb (WAW-250340)
Iron Age (c. AD 25 to c. AD 75)
Found in 2006 while metal detecting near Tanworth-in-Arden.

The Tanworth-in-Arden Iron Age comb was cast in bronze and decorated on both sides. Unusually, the decoration was also cast rather than being incised by hand once it was made. The decoration consists of two comma-leaf motifs growing from a central circular perforation with a cross-hatched background. Within each comma there is a crescent decorated with radiating ribbing, which is described as an 'armadillo' motif. The edge of the curved portion of the comb is decorated with a V-shaped groove. All the teeth are complete except for one at the end, which was lost in antiquity, and the comb was re-shaped to disguise this break, again in antiquity.

The 'armadillo' motif used to decorate the comb is seen on late Iron Age mirrors found at Holcombe, Devon, at Birdlip, Gloucestershire and at Desborough, Northamptonshire. These mirrors were deposited in around AD 40–70 and, based on the similar decoration, this date range probably applies to the comb as well.

The function of the comb is not certain. Due to the similarity in decoration to the mirrors, it is commonly thought to be for personal use, but another idea is that it may be a type of comb known as a curry comb, for horse's manes and tails, as it is very similar in size and shape to modern curry combs.

This comb is, as yet, the only late Iron Age copper-alloy comb that has been found in Britain.

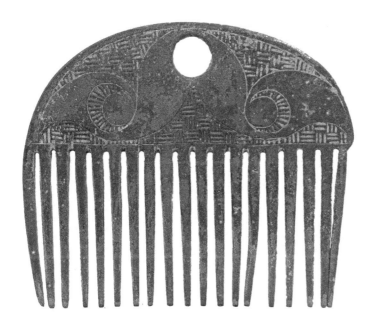

The Tanworth-in-Arden Iron Age comb. (WAW-250340)

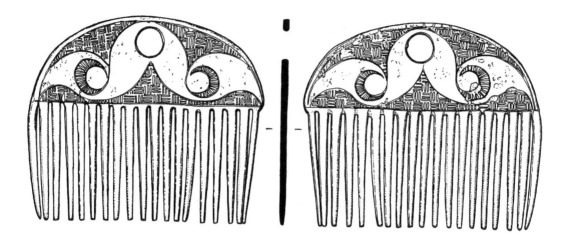

A technical drawing of the Tanworth-in-Arden Iron Age comb showing the profile and decoration in detail. (Illustrated by Candy Stevens)

The 'armadillo' motif found on Iron Age metalwork. (Illustrated by Angie Bolton.)

The pestle was found in 2007 while metal detecting near Ullenhall and the mortar was found in 2005 while metal detecting near Kingsbury.

Cosmetic mortars and pestles were used in the late Iron Age and early Roman period and are thought to have been used to grind minerals into a fine powder or paste for use as cosmetics. The pestle may have also been used as an applicator, as well as a means to grind the minerals.

In a similar manner to the Bronze Age razors, cosmetic sets are thought to have been suspended from a belt and possibly reflected the wearer's status, as these are not common objects.

Late Iron Age to Roman cosmetic pestles and mortars are found across Britain, but are only rarely found on mainland Europe, suggesting that they were made and used in Britain. Few cosmetic sets have been found in an archaeological context and the few that have been were found in burials.

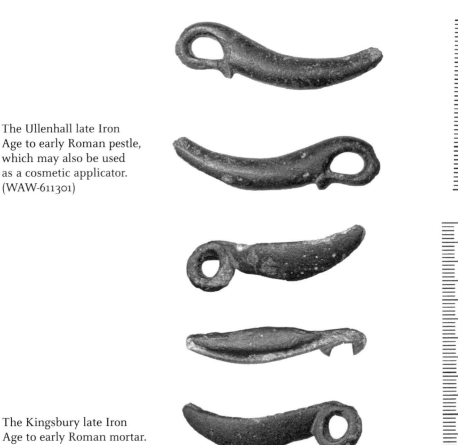

The Ullenhall late Iron Age to early Roman pestle, which may also be used as a cosmetic applicator. (WAW-611301)

The Kingsbury late Iron Age to early Roman mortar. (WAW-4E0706)

Chapter 5
The Romans in Warwickshire

(AD 43 to C. AD 410)

Forts, small towns, villas and farmsteads characterise Warwickshire in the Roman period. Roman towns include Alcester, Mancetter, Bidford-on-Avon and Chesterton. They may have all existed in the Iron Age as small settlements, but as their population increased they developed into small towns during the Roman period.

During this time, a network of roads became established in Warwickshire, with the Fosse Way, Ryknield Street and Watling Street passing through it, all of which were established to enable the Roman military to efficiently travel around the country. Other, smaller routeways would have been active in the Bronze Age and Iron Age, but they are not so visible in the archaeological record.

During the Roman period, we see an explosion in the amount of metalwork, pottery and coins being produced. Roman coins are the most common type of find the Portable Antiquities Scheme records, closely followed by brooches. This large rise is mainly due to increasingly sophisticated production methods and a growing monetary economy.

A coin hoard of thirty silver coins, known as *denarii*, was buried near Warwick during the early AD 160s. The earliest coin was a worn coin of Vitellius, a short-lived Emperor who died in the civil wars of AD 69. The latest coin is of Lucius Verus, from the first year of his joint reign with Marcus Aurelius in AD 161.

The hoard was probably the equivalent of a month's wages for an agricultural worker at this time and was deliberately buried rather than accidentally lost.

Coin hoards were often buried in periods of unrest to hide them, with the intention of later retrieving them. Coin hoards were also buried as an offering for ritual purposes, with no intention of them being recovered.

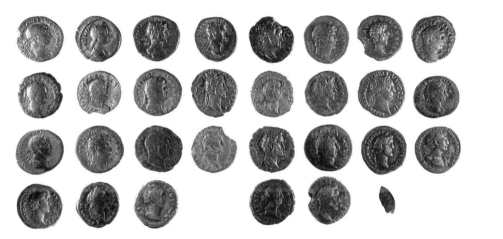

The Warwick Roman hoard showing all the obverses of each coin. (WMID-1AC648)

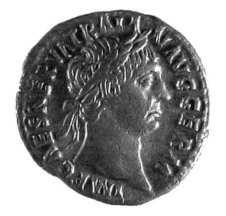
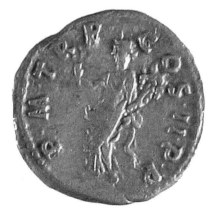

A close-up of a *denarius* of Trajan from the Warwick Hoard, depicting Pax on the reverse. It was minted in Rome between AD 98 and AD 117.

21. Bucket mount (WMID409)
Roman (c. AD 50 to c. AD 410)
Found in 1999 while metal detecting near Kingsbury.

Roman buckets were made of wooden staves and were decorated with bands of copper alloy and mounts, which often had a loop at the upper edge where the bucket handle was suspended. The Kingsbury mount depicts a bull or ox head and was one of thirteen such mounts known in 1999. At the time of writing, in 2017, there are over 120 examples known across the country, most of which have been recorded by the Portable Antiquities Scheme.

The Kingsbury mount is dated to the Roman period, based on the simplistic style and direction of the horns. The horns are pointing forwards and terminate with a blunt point. Other similar mounts have horns that point upwards and terminate with bulbous knops. The differences in the position and shape of the horns reflect differing farming practices and breeds of cattle. The mounts with bulbous knops are thought to date from the later Iron Age to early Roman period.

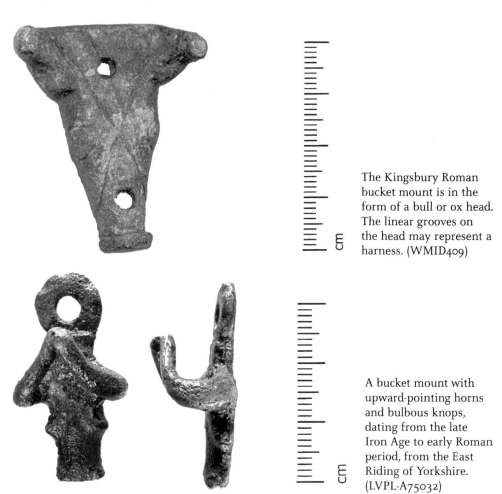

The Kingsbury Roman bucket mount is in the form of a bull or ox head. The linear grooves on the head may represent a harness. (WMID409)

A bucket mount with upward-pointing horns and bulbous knops, dating from the late Iron Age to early Roman period, from the East Riding of Yorkshire. (LVPL-A75032)

22. Brooch (Fibula: Polden Hill type) (WAW-C49D83)
Roman (*c.* AD 80 to *c.* AD 120)
Found in 2011 while metal detecting near Kineton.

After Roman coins, Roman brooches are the second most common Roman metallic finds recorded on the Portable Antiquities Scheme database. From the mid-first to second century, there was a wide variety of brooch styles, with the largest group being classed as fibulae. These brooches are broadly like a modern safety pin, although there are many variations in detail. Fibulae were used as fasteners, rather than being worn for purely decorative purposes.

The most common classification of brooch in the West Midlands and in Warwickshire is the Polden Hill type. This brooch is so much more common compared to other types that they were probably made in the West Midlands. The Kineton example is missing its pin, which is not unusual as the brooches are vulnerable to damage in the plough soil.

The only evidence we have of their manufacturing techniques are the surviving lead patterns. A pattern is a decorated model lead brooch, around which a clay two-piece mould is produced by pressing the pattern into the clay. Once the clay is fired, it becomes hard enough for bronze and silver brooches to be cast and for the mould to be re-used.

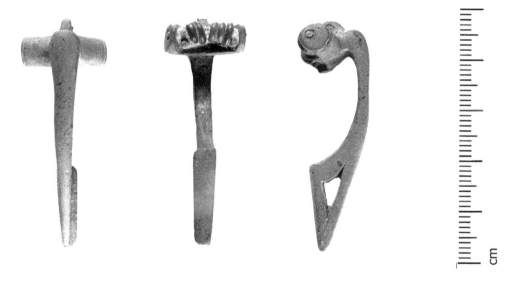

The Kineton brooch has a hump-like bow-head and semi-cylindrical wings with wing terminals encasing the axis bar and spring, which are features of the Polden Hill type. (WAW-C49D83)

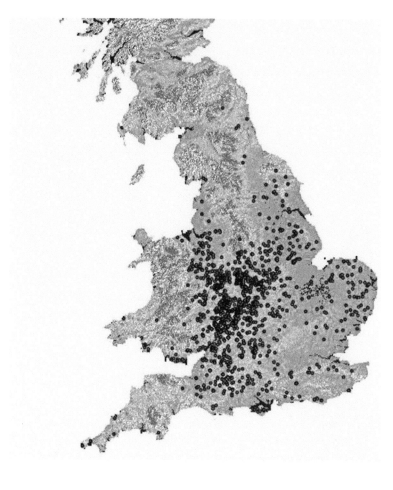

The distribution of Polden Hill type brooches across the country, with the main concentration being in the West Midlands. (*Contains OS data © Crown copyright and database right 2017*)

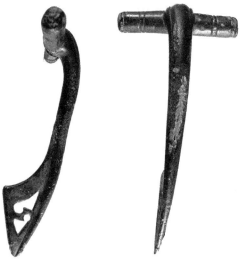
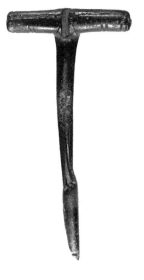

A T-shaped type of brooch. The hinged pin and tubular wings encasing the axis bar are the main features of this type of brooch. Found near Weston-on-Avon. (WAW-8DC613)

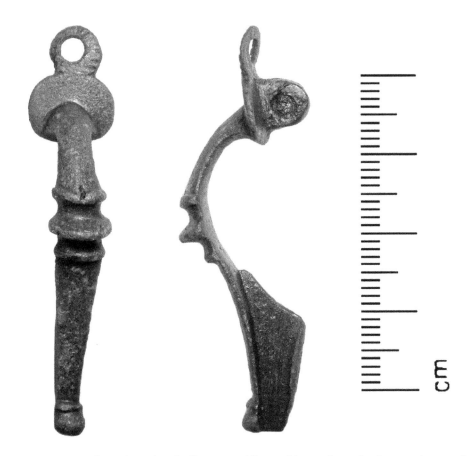

A Trumpet-type brooch with a bulbous moulding midway along the bow and an oval head. Found near Aston Cantlow. (WAW-80F1A1)

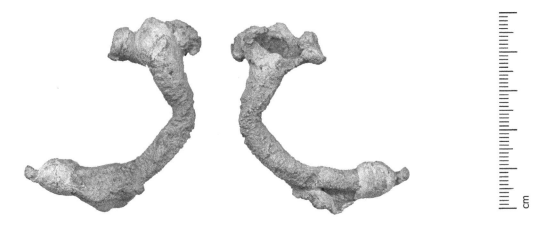

An example of a Polden Hill lead pattern, from which a clay mould is produced. Found near Chaddesley Corbett, Worcestershire. (WMID865)

23. Brooch (Plate: Tetraskelion type) (NMGW-798BAB)
Roman (*c.* AD 100 to *c.* AD 300)
Found in 2013 while metal detecting near Offchurch.

Roman brooches come in a variety of forms and the following are classed as 'plate' brooches. These brooches are typically flat, can be a variety of shapes and are often decorated with enamel or, rarely, gilding. Plate brooches have more similarities to modern brooches than safety pins as they were decorative rather than functional items. They are dated to the mid- to later Roman period.

The plate brooch from Offchurch is in the form of a tetraskelion. This form is found across the Roman Empire and not just Britain, but is not common. The tetraskelion is a pre-Christian symbol made up of four of the Greek capital letter gamma (Γ) and is also known as a gammadion cross. The Offchurch brooch is incomplete as it has two partial arms and the iron pin is missing.

Animal plate brooches are more common than the tetraskelion and the Fenny Compton example is in the form of a hare. The use of a hare may suggest a theme of hunting for the owner, but may also reflect the owner's continuing practice of the Celtic religion, where a hare was thought to be of particular significance.

Another form of plate brooch is the oval plate type, which is found almost exclusively in Britain. Oval plate brooches are often gilded and have a prominent glass gem in the centre. The Long Itchington example is well preserved, missing only its pin. This type of brooch would not look out of place today, although they actually date to the third to fourth century AD.

During the Roman period, a wider range of coloured enamels was used on artefacts to striking effect, particularly in plate brooches such as the examples from Alcester and Kineton.

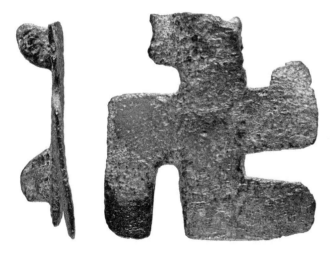

The Offchurch plate brooch in the form of a tetraskelion. (NMGW-798BAB)

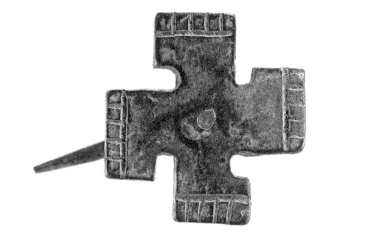

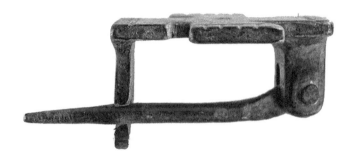

A complete example of a tetraskelion plate brooch from Cheshire. (LVPL-01AD05)

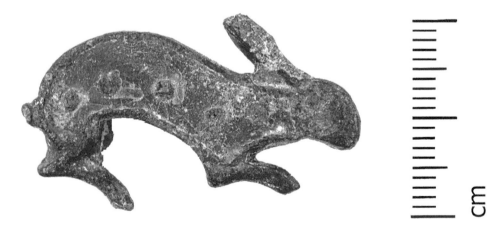

The Fenny Compton plate brooch is in the form of a hare and is decorated with blue enamel. (BERK-70B2A2)

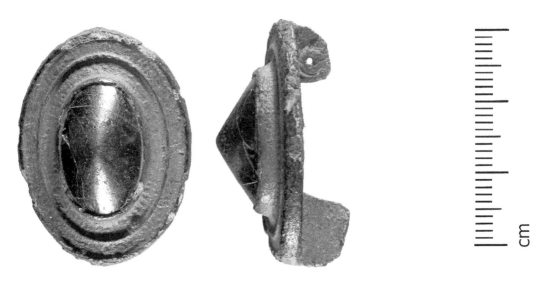

The Long Itchington oval plate brooch has a central glass setting and gilding. (WMID-D96326)

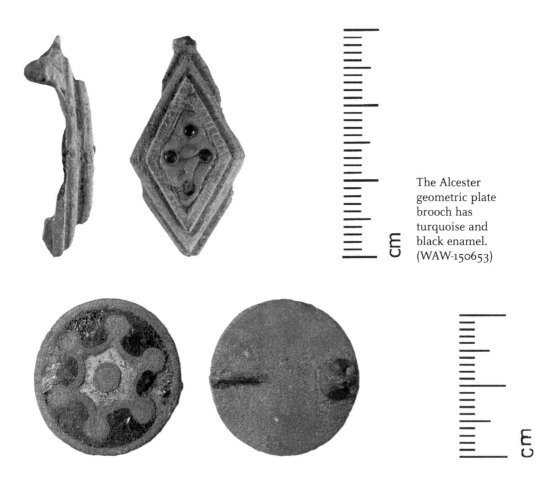

The Alcester geometric plate brooch has turquoise and black enamel. (WAW-150653)

The Kineton geometric plate brooch has dark blue or red enamel. (WAW-43C648)

24. Shoe or sandal (WAW-0685E3)
Roman (*c.* AD 43 to *c.* AD 410)
Found during 2013 while metal detecting near Newton.

The Newton sandal, or boot sole, is made from leather with iron hobnails. The sole comprises a leather outer sole, which faces the ground, a leather central sole (*lamina*), and then a thin leather inner sole, all of which are now incomplete and fragile. When viewed from the outer sole, the shoe is a sub-oval in plan with one lateral edge being slightly concave and the other being convex, suggesting it was worn on the left foot.

The outer sole has circular perforations, many of which are filled with iron dome-headed hobnails. The hobnails are positioned to form two rows, which follow the edge of the sole, and a single row, which fills the space on the heel and the front of the shoe, with additional nails in the centre.

The *lamina* also has perforations through which the hobnails are secured. Only the edges of the inner sole have perforations for the hobnails, whose shafts are bent down so as to make the inner surface smooth and to enable all the soles to be fixed together. The hobnails, as well as fixing the three soles together, also provide the shoe with grip.

There is no evidence of the upper construction of the footwear; therefore, it can't be identified as a sandal or boot.

An idea of what a Roman sandal would have looked like can be seen on a Roman knife handle recorded from the Darlington area, which clearly shows that the sandal was worn over a sock.

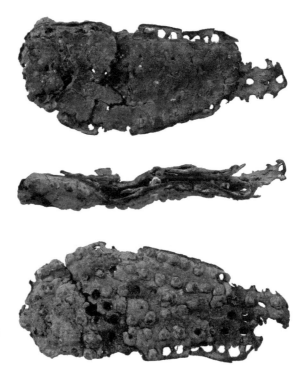

The Newton Roman sandal or boot sole made of leather with iron hobnails. (WAW-0685E3)

A Roman knife handle in the form of a leg with a sock and sandal over the foot. (NCL-920745)

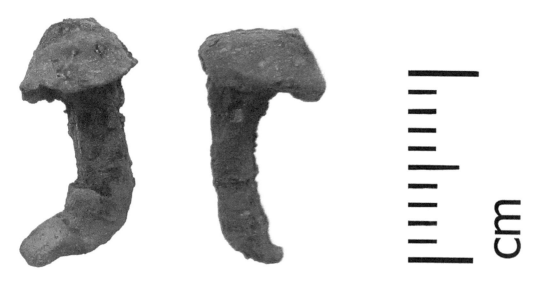

Roman hobnails from near Rugby, Warwickshire. (WAW-06D0C7)

The *nummus* of Diocletian (AD 284 – AD 305) from Radford Semele dates to AD 303 and is a rare coin, with only two other known examples. The coin was minted in Trier, Germany, and celebrates Diocletian's *vicennalia* (the twentieth anniversary of his reign) in September 303. On the reverse is the inscription 'VOT XX AVGG' within a wreath.

Roman coins are a common find in Warwickshire, and vary in the denominations and the metal from which they are struck. The earliest Roman coins are silver Republican *denarii* (the term *denarius* denotes a single coin), which were struck between about 211 BC and 27 BC. These coins were brought to Britain by traders and soldiers.

Other common denominations dating from the late first century BC to the mid-third century include *sestertii* (*sestertius* for a single coin), *dupondii* (*dupondius* for a single coin) and *asses* (an *as* for a single coin), all of which are made from copper alloy.

The rare Roman coins are those made of gold: first to early second-century *aurei* (*aureus* for a single coin) and late fourth to early fifth-century *solidi* (*solidus* for a single coin), although the Portable Antiquities Scheme has yet to record any from Warwickshire.

Other types of coins dating to the very end of the Roman period in Britain are the silver *siliquae* (*siliqua* for a single coin). These were produced between AD 324 and AD 356, and AD 358 and AD 411. These are rarer and the reverses are not as varied as in other denominations.

The most common denominations are the late third-century *radiates* and the fourth-century *nummi*, both of which are a mainly made of copper alloy.

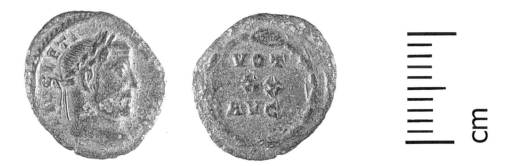

The Radford Semele copper-alloy *nummus* of Diocletian. (WMID-991F07)

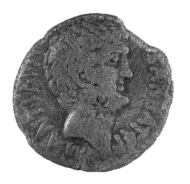 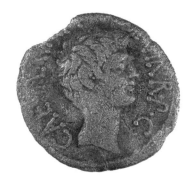

A silver Roman Republican *denarius* of Mark Anthony, which was minted in 41 BC. The obverse depicts Mark Anthony and the reverse depicts Octavian. The coin was found near Wroxall. (WMID-147A36)

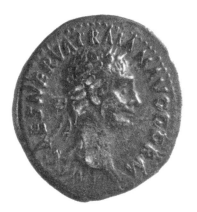 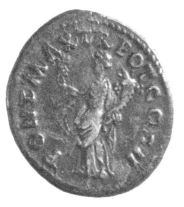

A silver *denarius* of Trajan that was minted in AD 98 and depicts Felicitas, the personification of prosperity, on the reverse. The coin was found near Lapworth. (WAW-F55978)

A copper-alloy *sestertius* of Faustina II that was minted AD 161 and depicts the goddess Venus on the reverse. The coin was found near Newton. (WAW-668EEA)

A copper-alloy *dupondius* of Marcus Aurelius that was minted between AD 153 and AD 155 and depicts the goddess Minerva on the reverse. This coin was struck in Rome, but was only issued in Britain. The coin was found near Ettington. (WAW-58B71C)

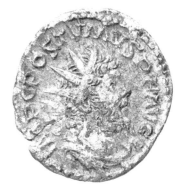

A silver and copper-alloy *radiate* of Postumus that was minted between AD 260 and AD 269 and depicts the Emperor holding a globe and spear on the reverse. The coin was found near Weston-on-Avon. (WAW-C9CBFF)

A copper-alloy contemporary copy of a *nummus* depicting the wolf and twins on the reverse. The coin was found near Offchurch. (WAW-D67DD6)

Chapter 6

The Early Medieval Period in Warwickshire

(AD 410 to AD 1066)

The period after the formal withdrawal of the Roman Empire is complex. Traditionally, it is thought that Warwickshire was settled by Anglo-Saxon tribes who had migrated from northern mainland Europe in the early fifth century. During the sixth to late eighth century, two kingdoms covered Warwickshire: the north was in the kingdom of Mercia and the south in the kingdom of Hwicce. By the late eighth century, Hwicce was assimilated into Mercia.

Finds of the fifth to eighth centuries are rare, and those that have been recorded are predominantly brooches and, in the eighth century, pins. When these artefacts are found it is usually a good indicator for a cemetery, and it is often metal detector users who are discovering previously unknown cemeteries by recording these objects.

In Roman Warwickshire, the largest proportion of finds recorded on the Portable Antiquities Scheme database are coins, but in the early medieval period, brooches and pins predominate. Coins only re-emerge in the early eighth century.

In the ninth century, the kingdom of Mercia diminished in size and importance. Warwickshire was bordered by Mercia to the west, the Danelaw to the east, and Wessex to the south. The Danelaw is where the Vikings had influence and here the law of the Danes was upheld, rather than the law of the Saxons. In Warwickshire, there are very few objects that are of true Viking origin. However, during the ninth century there is an expansion in the range of recorded metalwork and personal ornaments such as strap ends (which decorate the ends of belts) emerge.

The Portable Antiquities Scheme has recorded a large number of tenth- and eleventh-century horse-related finds from Warwickshire, such as strap fittings, stirrup mounts and components from bridles. This reflects the increased use of horses, and many of these finds demonstrate the decorative influence of the Vikings.

26. Disc brooch (WAW-F604A2)
Early Medieval (*c.* AD 550 to *c.* AD 575)
Found during 2005 while metal detecting in the Rugby area.

In the early medieval period, brooches were far less common than brooches in the Roman period. The Roman period saw the mass manufacture of brooches, whereas they were more individually crafted in the early medieval period.

The Rugby brooch is an example of a jewelled disc brooch, which was made from cast copper alloy and has been gilded to give it the appearance of gold. In the centre there is a large circular cell, which would have originally been filled with a jewel. Radiating from the central cell is a triple-stranded cross, whose arms terminate with smaller circular and square-shaped cells. Three of these smaller cells are filled with shell or white enamel and the other cells are now empty, although typically they would have been filled with slivers of polished garnet. Beneath the garnet it is likely there would have been a layer of punched gold foil, which enables light to be reflected through the garnet at multiple angles, enhancing the whole appearance of the brooch. The Staffordshire Hoard, which is on display at the Birmingham Museum and Art Gallery, has many examples of punched gold foil mounted behind garnets and is well worth a visit.

Between the cells, the brooch is decorated with interlacing, which represents the intertwining bodies of beasts – a typical form of decoration for metalwork of this period.

The overall pattern on this brooch has one close parallel on the Portable Antiquities Scheme database – a brooch fragment found near Brington in Northamptonshire, which is nearly thirteen miles from the Rugby example. The Brington brooch also has arms radiating from a central cell that terminate with smaller cells. The proximity of the two brooches suggests they were produced in the same workshop.

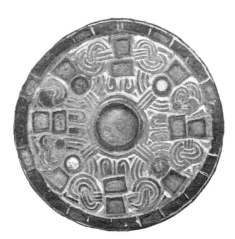

The Rugby jewelled disc brooch. (WAW-F604A2)

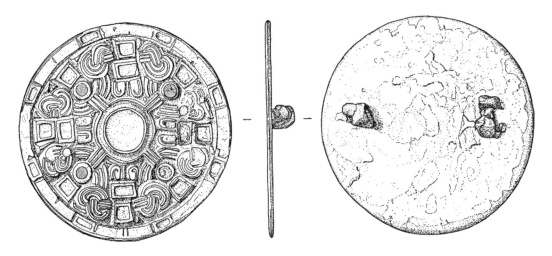

A technical drawing of the Rugby jewelled disc brooch, which highlights the detail of the decoration. (Illustrated by Candy Stevens)

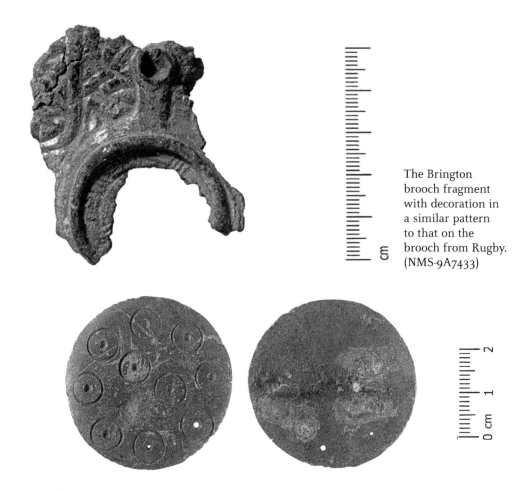

The Brington brooch fragment with decoration in a similar pattern to that on the brooch from Rugby. (NMS-9A7433)

A less decorated disc brooch from Brailes. (WAW-6EA8D2)

27. Shield mount (WAW-57ABoA)
Early Medieval (*c.* AD 500 to *c.* AD 700)
Found during 2014 and 2016 while metal detecting near Aston Cantlow.

The Aston Cantlow shield mount would have originally been riveted to the outer face of a wooden shield. The mount is in the form of a fish – probably a pike – and was found in two pieces: the tail in 2014 and the mouth in 2016 by the same finder. The mount is cast in copper alloy and has a gilded surface to give the appearance of gold.

There are a number of aquatic animal shield mounts known in Britain, but this is the first from Warwickshire. Other shield mounts occur in the forms of dragons and eagles, and all the mounts were considered to imbue the traits of the animals represented, such as protectiveness or aggression. It was believed that these traits were then passed to the user of the shield.

Excavated shield mounts are mainly found in male burials, perhaps indicating the importance or role of that male in their community. A few of the mounts have also been found in female burials, but these have been adapted to become jewellery.

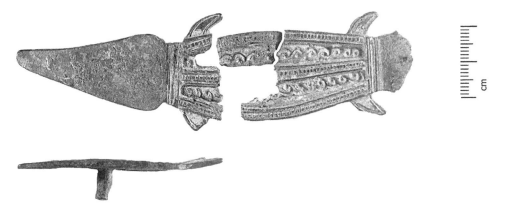

The Aston Cantlow shield mount in the form of a fish, which is thought to be a pike. (WAW-57ABoA)

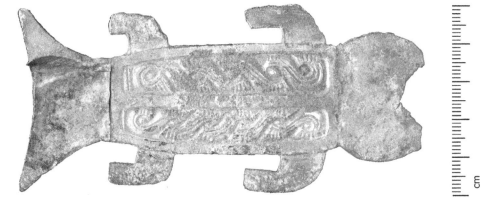

A similar example of a fish shield mount from Norfolk. (NMS-E2B508)

28. Grave goods (BERK-5105C9)
Early Medieval (*c.* AD 500 to *c.* AD 700)
Found during 2015 while metal detecting near Long Compton.

A metal detectorist discovered a copper-alloy long-handled pan, silver mounts and copper-alloy mounts from a wooden box. Best practice was demonstrated by the finder as he stopped detecting and contacted his local Finds Liaison Officer about these artefacts.

Due to the type of finds and the close proximity of the finds to each other, a controlled archaeological excavation was carried out by Finds Liaison Officers Anni Byard and David Williams, and the grave of an adult female was exposed, containing nearly forty artefacts. As one of the objects was silver, and over 300 years old, this and all the grave goods were reported under the Treasure Act (1996).

The excavation revealed the pan was buried in a wooden box, which was decorated with ten copper-alloy sub-rectangular mounts and a copper-alloy lock plate. There was a deposit of seeds to the left of the skull, which was possibly originally deposited within the wooden box.

The female skeleton, which was orientated on a south-north axis, was very well preserved. Around the neck was a fine copper-alloy chain, which was possibly associated with a ring-headed pin. Another round-headed pin was discovered level with the skeleton's nose, and was perhaps a pin to fix the shroud around the body.

Other grave goods that were present included a large amber bead and a faceted rock crystal on an iron chain. Upon lifting the skeleton, a large antler disc with a central perforation was found, which may have been a type of dress or hair accessory.

The burial was laid with the left hand situated on the pelvis, and the right hand apparently placed on top of a rock.

Research is continuing as any such find generates more questions: Where was this woman from? What did she die of? How old was she when she died? Was she an important person in her community?

The assemblage of finds is being acquired by the Ashmolean Museum.

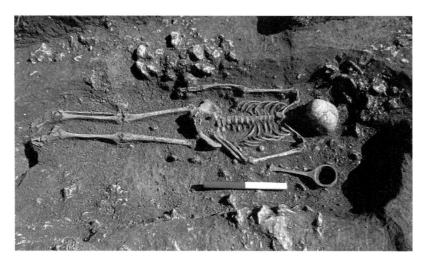

The excavated grave and grave goods in position. (Courtesy of David Williams)

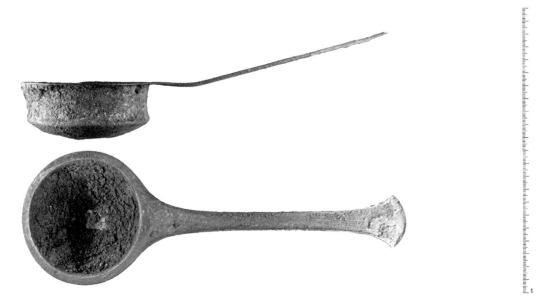

The Long Compton long-handled pan – one of the first finds discovered by the metal detector user. (BERK-5105C9)

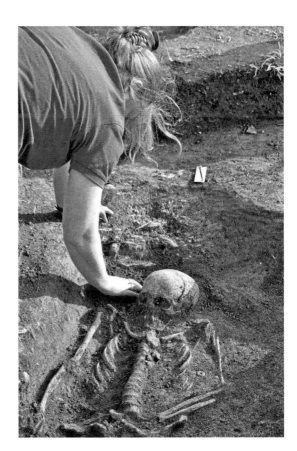

The grave being excavated by the Oxfordshire and West Berkshire Finds Liaison Officer, Anni Byard. (Courtesy of Anni Byard)

29. Weight or mount (SUR-307155)
Early Medieval (*c.* AD 700 to *c.* AD 900)
Found during 2012 while metal detecting near Lighthorne.

The Lighthorne artefact is an unusual early medieval object that, based on the decoration, dates from the eighth to ninth century.

The artefact is circular and domed, with a copper-alloy outer case that is filled with lead. Iron protrudes from the centre of the outer case, but is now truncated and may have been a suspension loop.

The outer case is decorated with a cross, whose centre is at the apex with the arms reaching to the lower edges of the artefact. Around the apex there are two concentric circles – one below the apex and one at the rim, forming a border for side panels, which are decorated with interlace and multi-stranded animals.

The use of large mounts as decorative bosses and the style of decoration are common on artefacts made in Ireland at this time. However, a boss or mount does not account for the use of lead or iron, so one theory is that it was originally an Irish boss that was re-used as a weight, possibly by the Vikings. The re-use of artefacts by the Vikings in this manner is not unusual.

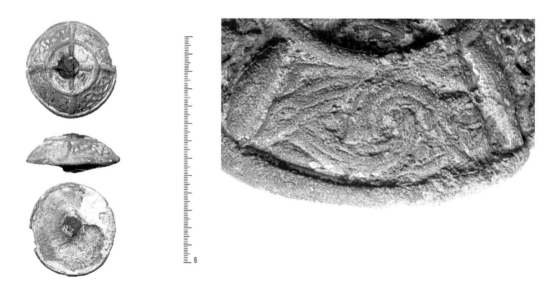

Left: The Lighthorne weight or mount showing the copper alloy outer layer, the iron protrusion and the lead-filled interior. (SUR-307155)

Right: A close-up of the multi–stranded, interlaced beasts on a side panel of the artefact.

30. Altar cross mount (WAW-3168EE
Early Medieval (*c.* AD 700 to *c.* AD 900)
Found during 2014 while metal detecting near Hampton Lucy.

The Hampton Lucy altar mount is an unusually large, cast-copper alloy mount in the form of a hollow, truncated pyramid. The upper face of the mount may have originally had a decorative setting as there is an irregular slot where a setting could be fixed. Each side face of the mount is decorated with five panels, each with an interlace design.

The mount is likely to date from the eighth to ninth century, based on its decoration. A similar mount has been discovered in Ireland, on the Tully Lough Cross, which is an Irish altar cross made of wood and covered with metallic mounts, and which has a large pyramidal mount at the centre.

Another similar mount, also thought to be Irish, was found in a church at Steeple Bumpstead in Essex. The Essex mount was found during construction work, where it was still in use as the chancel door handle. It was rediscovered in 1842 and is now in the collection of the British Museum.

The style and quality of decoration on the Hampton Lucy example suggests it was probably made in an Irish workshop.

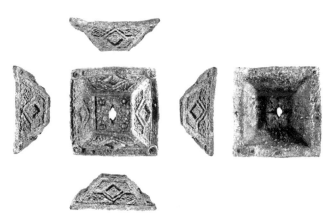

The Hampton Lucy altar cross mount showing the upper face and side views. (WAW-3168EE)

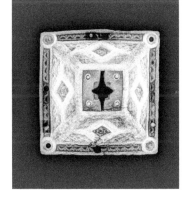

An X-ray of the mount reveals a crack on the upper face, which is not otherwise visible. (Courtesy of Birmingham Museums Trust)

31. Aestel (WAW-92EB56)
Early Medieval (*c.* AD 800 to *c.* AD 900)
Found during 2007 while metal detecting near Bidford-on-Avon.

An aestel is a manuscript pointer used to enable reading. The Bidford-on-Avon aestel, nicknamed the 'Bidford Bobble', is incomplete, as it is missing the pointing element, which was probably made of ivory. The aestel has a polyhedral head, which allows a portion of the head to lay flat on the page and to slide across it as the user reads.

The Bidford-on-Avon aestel is thought to be one of eight known examples commissioned by King Alfred (AD 871–899), who sent all the bishops in his kingdom his translation of Pope Gregory I's *Regula Pastoralis* (AD 590–604) along with an aestel.

All surviving aestels differ slightly in size, form and decoration, but most share typical features, including a domed body, a riveted socket and a flat base. The best known is the Alfred Jewel, which is the largest and most elaborate example. The Alfred Jewel was found in Somerset in 1693 and is now in the Ashmolean collection in Oxford.

The Bidford-on-Avon aestel has since been acquired by the Warwickshire Museum and is on permanent display.

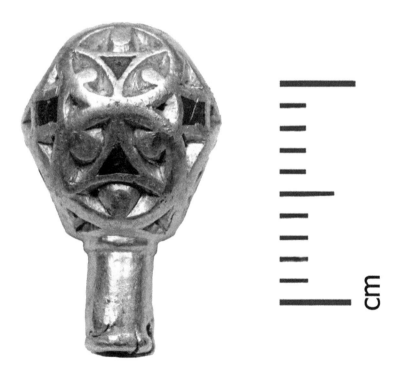

The Bidford-on-Avon aestel, which has the riveted socket but not the typical flat base. (WAW-92EB56)

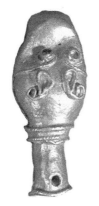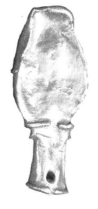

The Aston-cum-Aughton (Rotherham) aestel has a zoomorphic terminal and the typical features of an aestel. (SWYOR-C75C64)

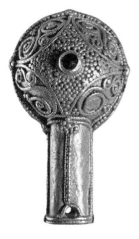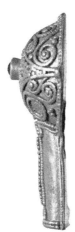

The Drinkstone (Suffolk) aestel has more elaborate decoration. (SF-3ABEB9)

The Whissonsett (Norfolk) aestal is an example made in copper-alloy. (NMS-AFFDBA)

32. Finger ring (PAS-D681D8)
Early Medieval (c. AD 900 to c. AD 1000)
The finger ring was found during 2001 while metal detecting in the Warwick area.

The Warwick gold finger ring has a hoop decorated with gold filigree and granules. The bezel is gold and decorated with cloisonné enamel. Cloisonné enamelling is a technique where enamel or glass of differing colours is separated by metal to form a cell, within which the enamel or glass is placed.

The quality of craftsmanship of the hoop and bezel are quite different in quality. The hoop is slightly crude; it has been made from a band of gold that expands in width to form a backplate for the bezel, and on which the decoration can be applied to the shoulder. The decoration on the shoulders is not symmetrical or as well accomplished.

The bezel, on the other hand, is of much higher quality craftsmanship. It is separate from the hoop and the join is hidden behind beaded wire. The craftsmanship of the cloisonné enamel is of excellent quality and is on a par with the enamelling that is mounted on ecclesiastical treasures.

The bezel and the enamelling were possibly produced in an Ottonian workshop in the Rhineland area, and dates to the tenth century. The hoop, due to its poorer craftsmanship, is thought to have been made in a different workshop on the Continent, but is still of Ottonian origin.

The finger ring would have been purchased on the Continent and imported to England, possibly as a gift.

The finger ring has since been acquired by the Warwickshire Museum and is on permanent display.

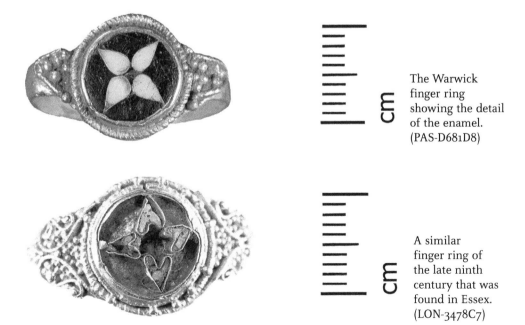

The Warwick finger ring showing the detail of the enamel. (PAS-D681D8)

A similar finger ring of the late ninth century that was found in Essex. (LON-3478C7)

33. Amulet (WAW-4CA072)
Early Medieval (c. AD 850 to c. AD 1066)
Found during 2006 while metal detecting near Billesley.

An amulet is an object that is thought to have a particular power associated with it, such as the ability to protect its owner from harm.

The Billesley fragment is from a larger object, but it is unknown what the object was. The two shorter edges of the Billesley fragment have been cut across a runic inscription, which is thought to be written in Latin. One inscription is well defined, with serif feet, and perhaps reads 'ADMO'. The last three of the four remaining runes have all been written as if they were joined, which is rare.

The inscription on the reverse is faint and therefore the runes are not clear enough to read.

Latin inscriptions on objects, rather than Anglo-Scandinavian inscriptions, tend to have Christian meanings. By having a Christian inscription on the item, it was thought that when held this fragment would enhance the power of prayers by the user, as well as offer protection.

The Billesley amulet showing the well-defined inscription. (WAW-4CA072)

34. Stirrup (WAW-989551)
Early Medieval (*c.* AD 1000 to *c.* AD 1050)
The stirrup was found during 2010 while metal detecting near Butlers Marston.

The Butlers Marston stirrup is an unusual find because it is made of iron – a metal which does not often survive well in the plough soil. It was made in the eighth to ninth century, and iron artefacts of this period are not often found. Metal detector users tend to ignore signals indicating an object is made of iron as they are usually modern finds. The Butlers Marston stirrup is the only example of its type on the Portable Antiquities Scheme database at the time of writing.

Stirrups dating from the eighth to ninth centuries are generally found in the Thames Valley, lower Severn Valley, East Anglia and Lincolnshire. These are all areas where the Vikings settled and, therefore, these stirrups tend to be associated with the Vikings.

A theory as to why it was found in Warwickshire, an area not settled by the Vikings, is that it was being used in the late tenth to early eleventh century, a time when war bands were travelling into and through Warwickshire, and the stirrup was then lost. There is evidence that stirrups were prized possessions by the Vikings and that, therefore, the stirrups may have become heirlooms, which may account for their length of use over 100 years later.

The stirrup has been kindly donated to the Warwickshire Museum by the finder.

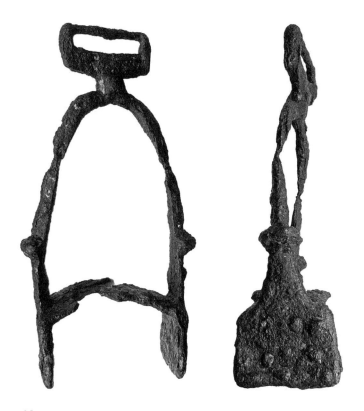

The Butlers Marston wrought iron stirrup. (WAW-989551)

Chapter 7
Medieval Warwickshire

(AD **1066** to AD **1541**)

Traditionally, the medieval period starts with the Norman Conquest in 1066 and continues until the Dissolution of the Monasteries in 1541. It is during this period that we see the origin of more of Warwickshire's towns and villages, including Atherstone, Bedworth, Nuneaton, Rugby and Stratford-upon-Avon. The landscape became increasingly developed as more small settlements and villages expanded to form towns, while ecclesiastical buildings and churches were built or enlarged. Large moated houses and castles were also built and refurbished, including those at Brinklow, Warwick, Kenilworth, Brailes, Studley, Fulbrook, Fillongley and Baginton. Evidence of medieval cultivation in the form of ridge and furrow earthworks (clusters of billowing linear ridges) can still be seen today.

It is during the medieval period that we see another increase in the number of artefacts being produced to satisfy demand. An example of this can be seen in changing fashions, with dresses and clothing becoming more tightly fitted, necklines becoming lower and hairstyles becoming more sophisticated. To achieve and accentuate these fashions, buttons, belts, girdles, hair pins and necklaces were needed.

Other artefacts became more widely available, such as decorative horse harness fittings in the form of gilded and enamelled pendants. Religious artefacts were increasingly seen, such as pilgrim badges and *ampullae* (small lead flasks filled with holy water), as well as religious inscriptions being found on items such as purse bars, seal matrices (the device used to impress sealing wax on a document) and jewellery.

The late medieval bridge at Bidford-on -Avon, originally built by the monks of Bordesley Abbey.

35. Buckle (WAW-CB5538)
Medieval (c. AD 1100 to c. AD 1200)
Found during 2016 while metal detecting near Temple Grafton.

The Temple Grafton buckle dates to the twelfth century and depicts the gaping mouth of a beast. The eyes and nose are visible on the outer edge of the frame, and towards the back of the head are two nubs for ears.

This style of buckle is unusual, with only forty examples known. None of these examples have been found on an archaeological excavation, so the dating of the buckle is based on its Romanesque style of decoration, which was popular in the twelfth century.

Medieval buckles, such as the Newbold Pacey and Lighthorne examples, are usually more recognisable, as they are similar to those used today. These types of buckle were used on straps such as for belts and spurs.

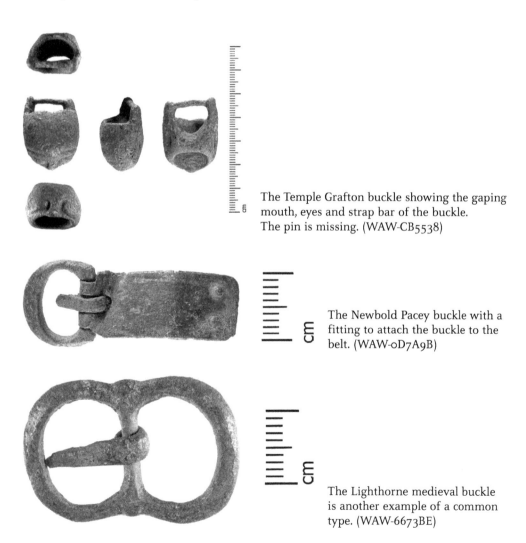

The Temple Grafton buckle showing the gaping mouth, eyes and strap bar of the buckle. The pin is missing. (WAW-CB5538)

The Newbold Pacey buckle with a fitting to attach the buckle to the belt. (WAW-0D7A9B)

The Lighthorne medieval buckle is another example of a common type. (WAW-6673BE)

36. Oil flask (WAW-FFC367)
Medieval (*c.* AD 1200 to *c.* AD 1400)
Found in 2011 while metal detecting near Wroxall.

The Wroxall copper alloy flask is part of a travelling chrismatory – a set of three holy oils used in the Catholic Church – containing *oleum infirmorum* for the sick, *oleum catechumenorum* for baptism and *chrisma,* or balm, to be used for confirmation, ordination and other consecrations.

The Wroxall flask is a simple, undecorated flask, but an example with an inscription reading 'OLEVM CRISM', meaning 'holy oil', was found by a metal detectorist in Surrey.

The flask may be associated with the nearby Wroxall Priory, which was built in the twelfth century for nuns of the Order of St Benedict.

Right: The Wroxall flask from a travelling chrismatory. (WAW-FFC367)

Below: A technical drawing of the Surrey flask with the inscription 'OLEVM CRISM' on the side. (SUR-FA2AB0) (Illustrated by David Williams)

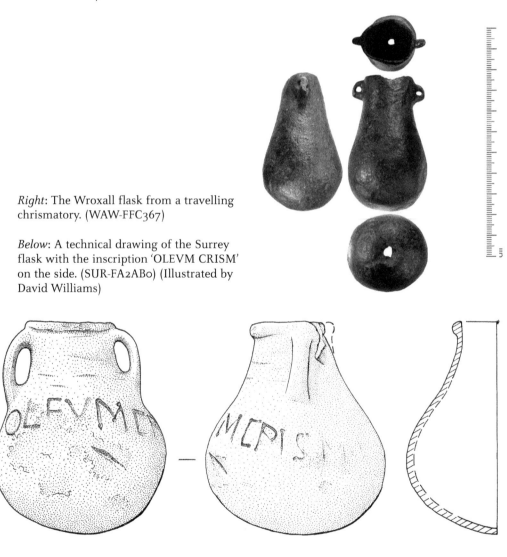

71

A papal bulla was used as a lead seal on official papal documents sent out from Rome as a means of authentication. The two types of documents to which these seals were attached are Letters of Justice and Letters of Grace. Letters of Justice were mandates that conveyed papal orders, prohibitions and injunctions, and the bullas were attached by hemp threads. Letters of Grace granted or confirmed rights and granted benefices. A silk cord was used to attach the bulla to these documents.

The Bidford-on-Avon lead papal bulla was attached to a papal *bulla* (the manuscript) issued by Pope Innocent IV, whose papacy lasted from AD 1243 to 1254. One face of the bulla depicts St Peter and St Paul below the inscription 'SPASPE' (SPA = Sanctus Paulus, SPE = Sanctus Petrus); St Paul is seen on the left looking right, with a long pointed beard, and St Peter is on the right facing left, with a rounded face and beard, and hair that is formed from pellets.

The reverse bears the legend 'INNO / CENTIVS / PP IIII', which sits within a beaded border. The legend gives the Pope's name – in this case Innocent IV – and the 'PP' is an abbreviation of *pastor pastorum*, meaning shepherd of the shepherds.

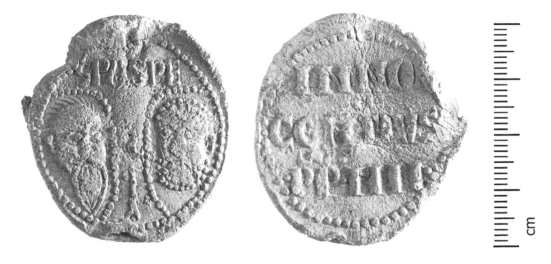

The Bidford-on-Avon papal bulla – the only remaining evidence of the document sent from Rome. (WAW-EC960A)

38. Strap mount (WAW-6EA4F3)
Medieval (*c.* AD 1200 to *c.* AD 1500)
Found during 2014 while metal detecting near Temple Grafton.

Strap mounts were used to decorate and strengthen leather straps, such as belts, girdles (a loose belt around the waist), harnesses, and those found on caskets and books. The Temple Grafton example would have been one of many mounts used on a single strap. Despite their small size and perhaps unglamorous appearance, collectively these mounts would have given the item they decorated an eye-catching appearance. It is these mounts that survive and not the leather straps they were originally fixed to.

The Temple Grafton mount dates to the thirteenth to fifteenth century, but the use of such mounts, albeit of differing styles, continued into the early post-medieval period.

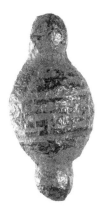 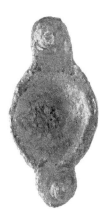

The Temple Grafton strap mount was likely to have been one of many mounts decorating a leather strap. (WAW-6EA4F3)

The Alcester strap mount dates to *c.* AD 1150 – *c.* AD 1475. (WAW-65532F)

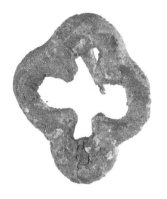

The Tredington strap mount is in the form of a quatrefoil with a perforation and dates to
c. AD 1500 – c. AD 1700. (WAW-B28319)

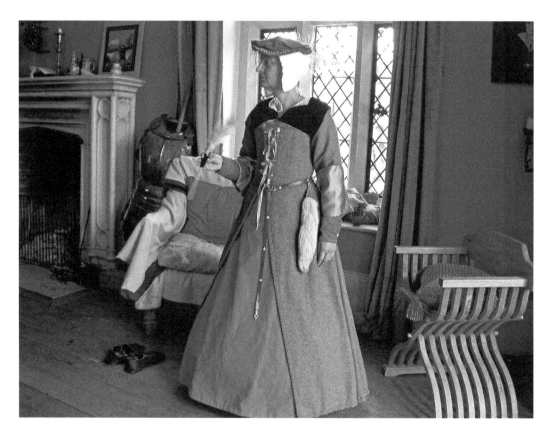

A re-enactor wearing a replica costume dating to c. AD 1540 – c. AD 1560, which includes a girdle
with strap mounts. (Courtesy of Ros Tyrrell)

39. Heraldic harness pendant (WAW-2938AD)
Medieval (c. AD 1225 to c. AD 1275)
Found during 2014 while metal detecting near Brailes.

In the medieval period, horse harnesses were decorated with pendants. They are usually made of copper alloy, which may then be gilded or tinned to give the appearance of gold or silver. Many pendants were also enamelled, using a variety of colours.

The Brailes pendant is decorated with a heraldic design depicting three wheatsheaves. The field around them would originally have been filled with enamel, but this is now missing.

Similar but higher-quality square pendants date to the early thirteenth century and tend to show the arms of the ruling houses of Europe, or the connected families. The Brailes pendant is a poor-quality copy of this type, as it is thinner and not as highly decorated, and it depicts the arms of an English family. Without the colour, the coat of arms is not closely identifiable, but it may have belonged to the Comyn family, who had a red shield with three wheatsheaves, or the Earldom of Chester, who had a blue shield with three wheatsheaves.

The Brailes harness pendant with the heraldic design of three garbs (wheatsheaves) just visible. (WAW-2938AD)

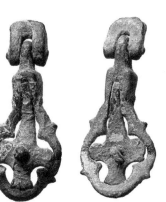

The Exhall harness pendant is made of two parts, in which the central portion swings within its frame. It dates to c. AD 1200 – c. AD 1400. (WAW-1EA914)

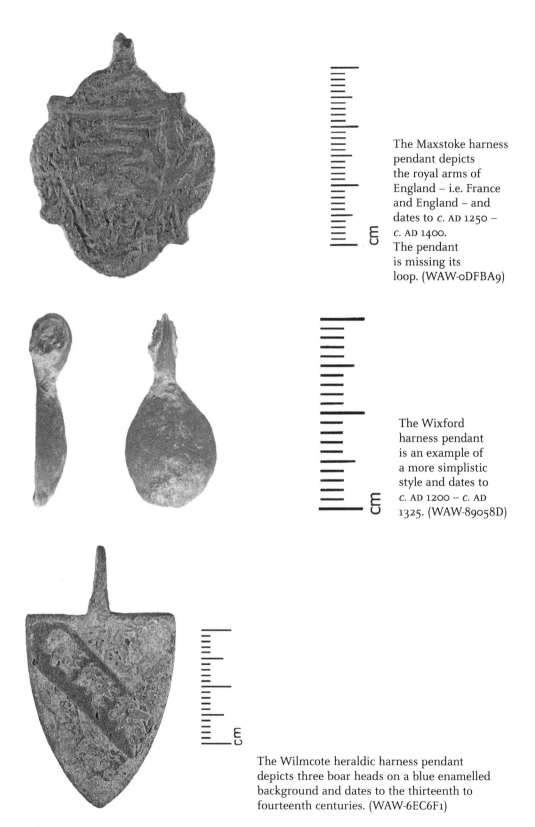

The Maxstoke harness pendant depicts the royal arms of England – i.e. France and England – and dates to *c*. AD 1250 – *c*. AD 1400. The pendant is missing its loop. (WAW-0DFBA9)

The Wixford harness pendant is an example of a more simplistic style and dates to *c*. AD 1200 – *c*. AD 1325. (WAW-89058D)

The Wilmcote heraldic harness pendant depicts three boar heads on a blue enamelled background and dates to the thirteenth to fourteenth centuries. (WAW-6EC6F1)

In AD 1279, Edward I reformed the coinage of England, changing the appearance of the coin and expanding the different denominations available to include farthings, halfpennies and groats. The coins of Edward I now had a lifelike crowned bust and a longer inscription detailing the King's titles in England, France and Ireland. The shorter inscription on the reverse no longer provided the moneyer's name, just the city where the coin was minted.

The busts of Edward I's predecessors, for example Henry III (reigned 1216–1272), were more simplistic and cartoon-like. The inscription would bear only their name, while the reverse would give the moneyer's name and the city the coin was minted in.

Pennies are the most common denomination of Edward I's coins that are found in Warwickshire; the smaller halfpennies and farthings account for only 13 per cent of Edward I's coins. During the reign of Henry III, halfpennies and farthings were made by cutting a penny in half or quarters. As this small change was easily made by the people spending the coins, they were more common. Halfpennies and farthings from the reign of Henry III account for 33 per cent of the coins of Henry III in Warwickshire.

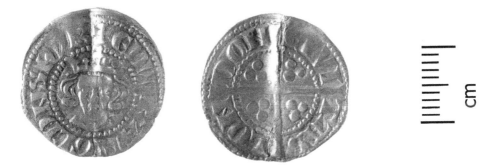

The penny of Edward I found near Tanworth-in-Arden. (WAW-1A29F8)

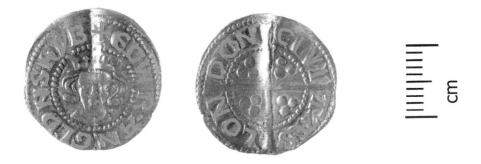

The Tanworth-in-Arden penny with the inscriptions highlighted. 'EDW R ANGL DNS HYB' translates as Edward, King of England, Lord of Ireland. The inscription on the reverse gives the city in which the coin was minted. (WAW-1A29F8)

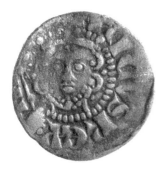

A penny of Henry III showing the more simplistic bust. The reverse reads 'IOh ON CANTER', which translates as Jon at Canterbury. The penny was found near Wroxall. (WAW-877515)

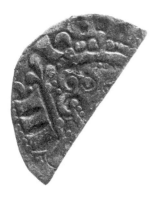 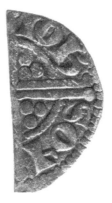

A cut halfpenny of Henry III minted in Canterbury by Jon, which was found near Wixford. (WAW-813D8A)

A cut farthing of Henry III minted by Nicole, which was found near Tanworth-in-Arden. (WAW-B23E2C)

41. Brooch (WAW-D42D94)
Medieval (*c.* AD 1200 to *c.* AD 1325)
Found during 2014 while metal detecting near Weston-on-Avon.

One of the uses of brooches in the medieval period was as a romantic gift while couples were courting, and the inscriptions on the Weston-on-Avon brooch suggest a romantic theme.

One inscription reads 'AMVR VENT TVTEN', which is a variant of the common Latin inscription *Amor Vincit Omnia*, or Love Conquers All, but is abbreviated from the French version (*amour vainc tout*) rather than the Latin. The second inscription reads 'IO SVI FLUR DE LEL IA', meaning I Am The Flower Of Loyal [Love].

There are other romantic brooches found in Warwickshire; for example, a brooch found near Wootton Wawen (WMID-86D485), which dates from the thirteenth to fourteenth century and is set with sapphires and rubies.

Not all such brooches were decorated. The plain example from Princethorpe (WAW-3259EB), for example, did not diminish the romantic meaning because of the lack of decoration.

The Weston-on-Avon brooch was declared Treasure and was acquired by the Warwickshire Museum.

The Weston-on-Avon brooch with the inscription reading 'AMVR VENT TVTEN' on one side and 'IO SVI FLUR DE LEL IA' on the other. (WAW-D42D94)

The brooch from Wootton Wawen decorated with sapphires and rubies. (WMID-86D485)

The undecorated brooch from Princethorpe. (WAW-3259EB)

42. Pendant (WMID-BC01F1)
Medieval (*c.* AD 1475 to *c.* AD 1500)
Found while metal detecting near Middleton during 2014.

A pendant is a suspended ornament and, in the case of the Middleton pendant, was probably from a necklace. The Middleton pendant is incomplete, with only the backplate remaining. The outer face depicts the armour-clad St George, standing with the dragon between his feet as he thrusts a lance into the back of the dragon's head.

The legend of St George portrays a dragon tormenting people in what is now Libya. According to the legend, local people fed the dragon sheep to appease it and, when sheep were scarce, it was fed people – one of whom was the king's daughter. Just before being sacrificed, George saw her weeping, and on hearing about her situation told her not to be afraid, and that in the name of Christ he was going to help her. George went on to wound the dragon and led the dragon towards the city on a lead, where he declared to everyone that he would slay the dragon if they believed in Christ and were baptised. As people wanted the dragon to die they agreed to his terms, and a church in the names of St Mary and St George was built where the slaying occurred. According to the legend, 'from its altar flowed a spring whose waters cure all disease', and the church became a destination for pilgrims.

By wearing the image of St George close to your skin, his perceived healing traits and his ability to bring livestock good health (slaying the dragon is a metaphor for livestock being saved from an untimely death) were thought to be strengthened and would benefit the wearer.

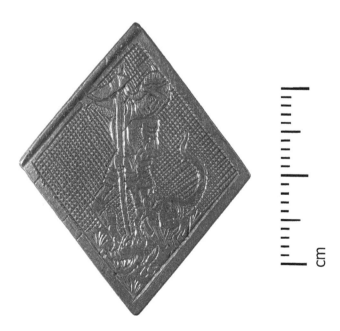

The backplate of the gold pendant engraved with St George slaying the dragon. (WMID-BC01F1)

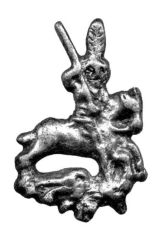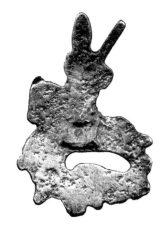

A pilgrim badge depicting St George slaying the dragon, which was found in Dorset. (DOR-9BC000)

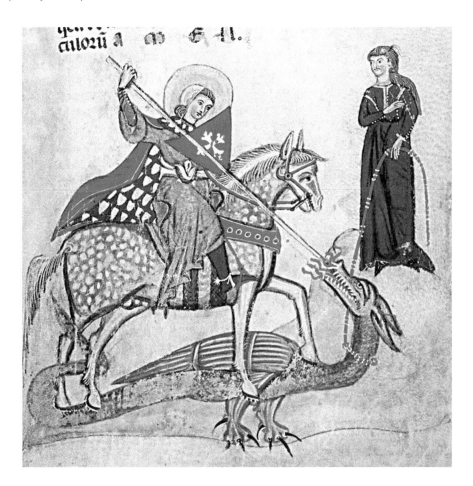

A depiction of St George slaying the dragon produced *c*. 1270. (CC-PD-MARK Verona, Biblioteca Civica, ms 1853, f.26r)

A complete medieval pendant found in Essex depicting either the Virgin Mary or St Helena. The back panel of the pendant slides across to reveal a void within, in which a relic was probably contained. (ESS-2C4836)

Chapter 8

Post-Medieval Warwickshire

(*c.* 1541 onwards)

The post-medieval period is defined by changes in society, which can be seen in the landscape and the increasingly prolific finds from this period.

In Warwickshire, major events were witnessed, including the Dissolution of the Monasteries during the reign of Henry VIII and the subsequent transfer of land and assets to the Crown. During 1642, the first battle of the English Civil War between the Royalists (Cavaliers) supporting King Charles I and the Parliamentarians (Roundheads) took place at Edge Hill, near Kineton.

In 1694, a large portion of Warwick caught fire, and as a result new buildings were required to be built with tiled roofs.

The landscape evolved as well. Until the seventeenth century, farming had taken place on large communal open fields, but agricultural land subsequently became enclosed by hedges and fences. With the authorisation of an Act of Parliament, holdings were consolidated into rented or owned fields instead of the large open fields.

Finds from the post-medieval period are prolific and the Portable Antiquities Scheme has had to be selective as to what it records or it would be overwhelmed. Artefacts and coins less than 300 years old tend not to be recorded. Any artefacts post-1700 are recorded if they are considered to have particular historical or regional importance.

43. Dress hook (WAW-A43DB3)
Post-Medieval (*c*. AD 1500 to *c*. AD 1600)
Found during 2013 while metal detecting near Great Wolford.

A dress hook is used to join two parts of clothing together and can be ornate, as the Great Wolford example is, or more simplistic in design and manufacture, such as the Honington example. The Great Wolford silver dress hook has a number of different components; the back-plate, a rectangular loop, a hook, a central stud, and three large hemispherical domes. Each dome is decorated with three single-strand 'rope-twist' filigree wire circlets with a smaller domed pellet at the apex. Gilding has been added to enhance the decoration.

Dress hooks of similar form have been frequently reported in recent years under the Treasure Act (1996), as many are made of precious metal and are more than 300 years old. Prompted by the increased reporting of dress hooks, research has been carried out and they are thought to be used as a type of dress fastener or as decoration in the sixteenth to seventeenth century. Contemporary paintings, such as Holbein the Younger's *English Woman in Contemporary Dress* and Bruegel the Elder's *Peasant Dance*, are used as a visual source of evidence for dress hook use, and suggests that the wealthy and not-so-wealthy used such hooks, but of differing metals.

The most common examples, and the cheapest to make, are those cast in copper alloy. The Coughton dress hook is a copper-alloy copy of the silver type found at Great Wolford. The copy has traces of a white metal coating, which was used to give the impression that it was made of silver.

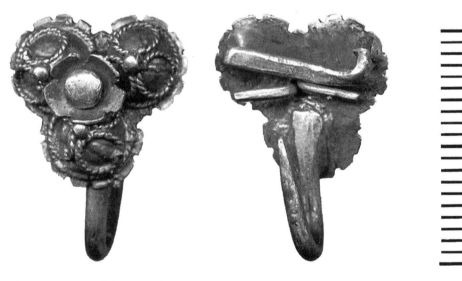

The Great Wolford dress hook showing the composite parts. (WAW-A43DB3)

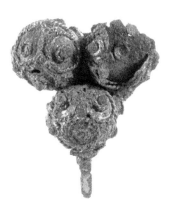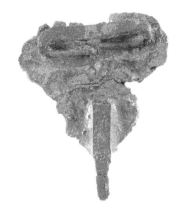

The Coughton dress hook is a copper-alloy copy of the Great Wolford-style dress hook. (WAW-DC8C7B)

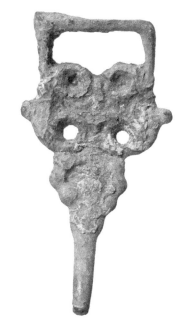

The Honington dress hook, which is a common, mass-produced example. (WAW-C87620)

An unusual lead dress hook from Newbold Pacey. (WAW-D7F538)

This post-medieval coin is a silver *soldino* of the Doge Leonardo Loredan, which was minted in Venice between 1501 and 1521. The Doge was the chief magistrate and leader of the State of Venice. On the obverse, the Doge is kneeling, holding a banner, and the reverse depicts the standing figure of Christ.

Soldini were known as galley-halfpence, as they were brought to Britain by the visiting Venetian trading fleets. The *soldino* was approximately the size of an English halfpenny and were popular because of a lack of small change in England at the time. In fact, *soldini* are more commonly found than the English halfpennies of the period.

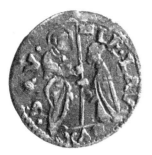 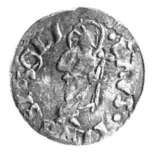

The *soldino* of Doge Leonardo Loredan, which was minted in Venice between 1501 and 1521. (WAW-6497E2)

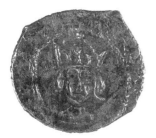 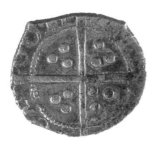

A halfpenny of Henry VII minted in London between AD 1485 and 1509, which would have circulated with the more common Venetian *soldini*. This halfpenny was found in Worcestershire. (WAW-B2F058)

Towards the end of Henry VII's reign, the busts on the coins changed in style, depicting him now in profile and being recognisable as the monarch. The reverse (tails side) of the coin became heraldic, displaying the royal coat of arms rather than having a cross and three pellets in each quarter. This style of coin continued into the reign of Henry VIII.

It was during the reign of Henry VIII that coins were debased by reducing the amount of silver in each coin while the coin circulated at its face value. The savings in silver were to help finance Henry's wars against Scotland and France in the latter years of his reign.

The halfgroat from Brailes is damaged, probably by ploughing, but along the broken lower edge, corroded copper is visible beneath the silver. The heavy debasement of such coins led Henry VIII to be nicknamed 'Old Coppernose', as the silver on his nose was often worn through, revealing the copper beneath.

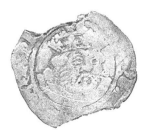 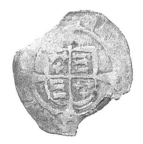

Halfgroat of Henry VIII revealing the copper alloy core. (WAW-B97513)

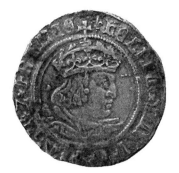 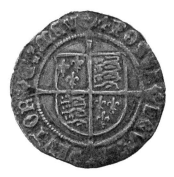

Groat of Henry VIII minted between 1526 and 1544 found near Shilton, with a high silver content. (WAW-F24806)

46. Cloth seal (WMID-C19DF1)
Post-Medieval (*c.* AD 1600 to *c.* AD 1700)
Found during 2013 while metal detecting near Wroxall.

From the fourteenth to eighteenth century, lead cloth seals were attached to mass-produced cloth by quality control officers to both certify their quality and to confirm a tax had been levied on the cloth.

The Wroxall cloth seal would have been attached to cloth imported from Haarlem in the Netherlands during the seventeenth century. The seal bears the coat of arms for Haarlem on one side and a '20' appears on the other side, which measures the length of the cloth in ells. An ell is the length of a man's arm from the elbow to the tip of the middle finger.

Cloth exported from Haarlem was a fine linen known in England as 'holland'. The cloth was not woven in Haarlem, but was finished there by bleaching the linen in the waters along the Kennemerland coast.

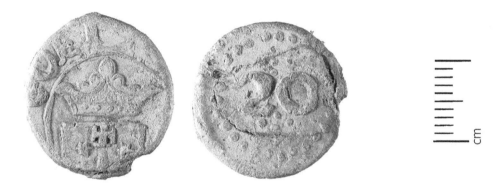

The Wroxall cloth seal originally attached to linen from Haarlem, Netherlands.

A cloth seal found near Shipston-on-Stour which originated on cloth exported from Augsburg, Germany, dating to the sixteenth to seventeenth centuries. The Augsburg seals are found across England, accounting for a third of all Continental seals recorded in England.

A seal matrix is the device with which an impression is made on wax that sealed, or was attached to, a document. The motif on the face of the Billesley seal matrix depicts a heraldic shield, the arms of which were granted to the Lee family of Billesley, Warwickshire, on 20 December 1593 by the College of Arms.

The history of the family and its relationship to Billesley began in 1600, with Robert Lee buying Billesley Manor for £5,000. In 1602 he became Lord Mayor of London and was knighted, but he died in 1605. His second son, Robert, inherited Billesley Manor and he also used the Lee family coat of arms, until his death in 1638.

A motif consisting of a crescent surmounted by a horizontal line (known as a label) was added to the arms on the seal matrix. This indicates that the seal was passed on to the second Robert Lee's eldest son, also called Robert Lee of Billesley, who died aged fifty-seven in 1659.

The seal matrix must have been recut to add the label before 1638, the year of his father's death, after which the second Robert Lee was no longer required to use it.

On the death of the third Robert Lee in 1659, Billesley Manor passed first to his daughter, and then to his brother Charles, who eventually sold it in 1689.

The seal is unusual in that we can confidently identify the person for whom it was cut, namely Sir Robert Lee (d. 1659), prior to his father's death in 1638.

The seal matrix was acquired by the Warwickshire Museum.

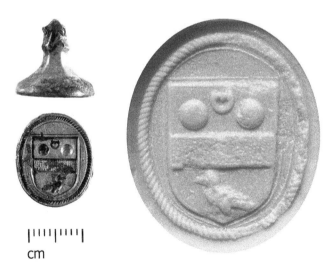

cm

Left: The Billesley seal matrix of the Lee family. (WAW-5EF2D8)

Right: A recent impression of the Billesley seal matrix. (WAW-5EF2D8)

48. Sword belt fitting (WAW-D88A67)
Post-Medieval (*c.* AD 1550 to *c.* AD 1650)
Found between 2014 and 2015 while metal detecting near Brailes.

The mid-sixteenth to seventeenth-century Brailes sword belt fitting would have attached a sword scabbard to the belt of the wearer. The leather scabbard would be fitted with a hook and suspended from the belt fitting. Sword belt fittings such as these were commonly worn by soldiers in the Civil War.

The sword belt fitting has traces of a black substance, most likely linseed oil, which was originally used to polish the metalwork.

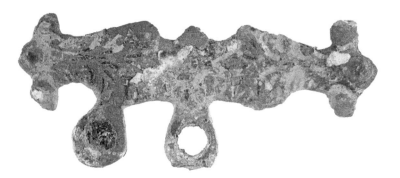

The Brailes sword belt fitting showing traces of black coating from the linseed oil which would have been used to polish the fitting. (WAW-D88A67)

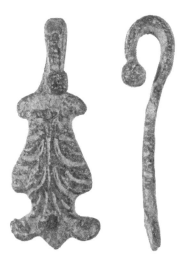

Another Brailes sword belt fitting which would have attached to the scabbard, also from Brailes. (WAW-D8A15C)

90

Civil War re-enactors illustrating the weaponry and costume of soldiers. (Copyright of Museums Worcestershire)

An incomplete and broken sword belt and scabbard fittings found together in Hampshire, decorated with the initials IHS which is an abbreviation of Jesus. (HAMP-2F32E8)

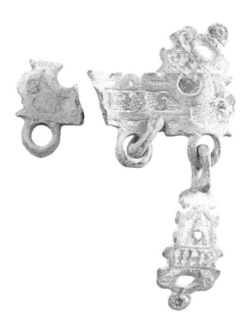

49. Russian lead seal (WAW-6F85F4)
Post-Medieval (AD 1785)
Found in 2006 while metal detecting near Henley-in-Arden.

In the eighteenth and nineteenth centuries, Russia was the world's largest exporter of flax and hemp, which Britain imported. Attached to the bundles of flax and hemp were lead seals, which provided information such as the quality grade of the product, the name of the Quality Control Officer applying the seal, the date and the port of origin. The main Russian ports from which such products were exported included St Petersburg, Archangel, and Riga.

For the Henley-in-Arden seal, the port of origin is unknown. However, 'АНТОН ОВѢ' is the Quality Control Officer's initial and surname, and 'H234' is the post where the Officer was based. The letters 'NP' indicate that the product to which the seal was attached was flax and the letters 'LI' are the initials of the grower or agent of the flax. The 'W18' is thought to be the grade of quality of the flax. The seal is dated 1785, which is the year the flax was inspected.

Such seals provide evidence of the products being imported into Britain, as well as the origin of these products. Eighteenth- and nineteenth-century seals from Russia and the Netherlands have been found in Warwickshire.

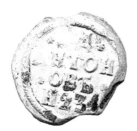

The Henley-in-Arden Russian seal dates to 1785 and would have been attached to flax.

A lead seal found in the parish of Baddesley Ensor which originated from the Dutch Custom House and depicts the heraldic arms of the House of Orange. The seal dates to the eighteenth to nineteenth centuries. (WMID-72B878)

Tokens were produced to fulfil a need for small denominations during the latter half of the seventeenth century, the late eighteenth century and again in the nineteenth century.

The Stratford-upon-Avon copper-alloy threepence token was issued between 1859 and 1861 by Samuel Young of the Racket Court Inn, Bath Street, Birmingham.

Bath Street Racquets Club was formed beside the Welch Harp public house in 1859. Players would meet at the club to play a newly devised game called racquets, a forerunner to tennis and squash. In 1859, the public house changed its name to the Racquet Court Inn and records show that Samuel Young of Birmingham was also licensed to sell alcohol in the Inn. Unfortunately, Samuel Young was made bankrupt in 1861.

An example of a seventeenth-century token was found in the parish of Leamington Hastings and was issued by Edward Taylor, the Bailiff of the Hemingford Hundred in Huntington, Cambridgeshire. This is an unusually well-travelled token for this period.

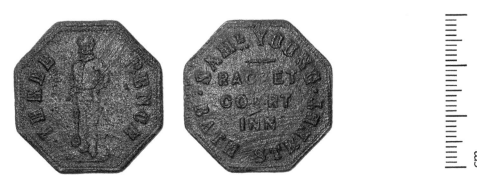

Trade token issued by Samuel Young of the Racket Court Inn, Bath Street, Birmingham. (SUR-AD67A1)

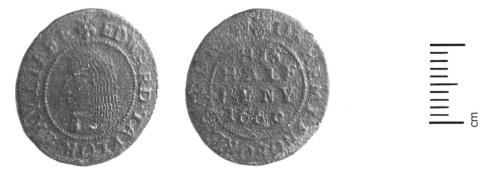

The seventeenth-century token found in the parish of Leamington Hastings and was issued by Edward Taylor, the Bailiff of the Hemingford Hundred in Huntington, Cambridgeshire. (WAW-FFA763)

Further Reading and Resources

Books

Barber, M., *Bronze and the Bronze Age: Metalwork and Society in Britain c. 2500 – 800 BC* (Stroud: Tempus, 2003).

Bayley, J. and Butcher, S., *Roman Brooches in Britain: A Technological and Typological Study Based on the Richborough Collection* (London: Society of Antiquaries, 2004).

Butler, C., *Prehistoric Flintwork* (Stroud: Tempus, 2005).

Dickenson, M., *Seventeenth Century Tokens of the British Isles and Their Values* (London: Spink, 2004).

Egan, G., *Lead Cloth Seals and Related Items in the British Museum* (London: British Museum Occasional Paper 93, 1994).

Egan, G., *The Medieval Household: Daily Living c. 1150 – c. 1450* (London: The Stationary Office, 1998).

Egan, G., *Material Culture in London in an Age of Transition* (London: Museum of London Archaeology Service Monograph 19, 2005).

Egan, G. and Pritchard, F., *Dress Accessories c. 1150 – c. 1450 (Medieval Finds from Excavations in London)* (London: Boydell Press, 2002).

Gaimster, D., 'Tudor Silver-Gilt Dress Hooks: A New Class of Treasure Find in England' *Antiquaries Journal* Volume 82, pp. 157–196. (2002).

Harvey, P. D. A. and McGuinness, A., *A Guide to British Medieval Seals* (London: British Library and Public Record Office, 1996).

Jackson, R., *Camerton: The Late Iron Age and Early Roman Metalwork* (London: British Museum Press, 1990).

Jope, E. M., *Early Celtic Art in the British Isles* (Oxford: Clarendon Press, 2000).

Kelleher, R., *A History of Medieval Coinage in England* (Essex: Greenlight Publishing, 2015).

Kiernan, P., *Miniature Votive Offerings in the Roman North West* (Verlag, 2009).

Lewis, M., *Saints and their Badges* (Essex: Greenlight Publishing, 2014).

Moorhead, S., *A History of Roman Coinage in Britain* (Essex: Greenlight Publishing, 2013).

Seaby, W. A. and Woodfield, P., 'Viking Stirrups from England and their Background' *Medieval Archaeology* Volume 24, pp. 87–112. (1980).

Websites
Warwickshire County Council/Warwickshire Museum Timetrail:
http://timetrail.warwickshire.gov.uk/

Warwickshire Museum Service:
http://heritage.warwickshire.gov.uk/museum-service

Warwickshire Historic Environment:
http://heritage.warwickshire.gov.uk/archaeology/historic-environment-record/

Roman Finds Group:
www.romanfindsgroup.org.uk

Finds Research Group:
www.findsresearchgroup.com

Late Prehistoric Finds Group:
https://sites.google.com/site/laterprehistoricfindsgroup

Portable Antiquities Scheme:
www.finds.org.uk

Council for British Archaeology (West Midlands):
http://cbawm.archaeologyuk.org